# RIVER WELLAND

## DOROTHEA PRICE

AMBERLEY

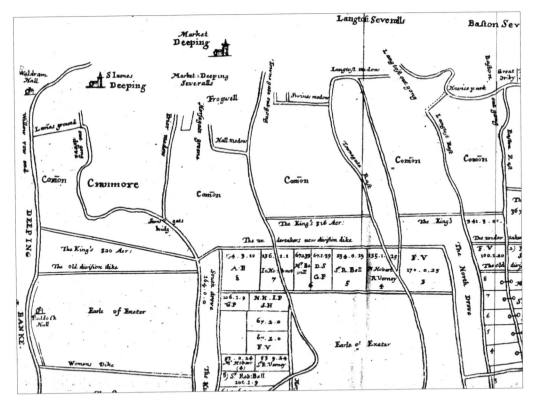

*Above:* From Dugdale's 1772 edition of *Imbanking and Draining the Fens.*

*Front cover illustrations:* Boating on the River Welland c. 1912 adjacent to Eastgate with the priory church dedicated to St James in the distance; Tallington watermill with the mill stream in the foreground.

*Back cover illustrations:* Stamford near the meadows; Tug-of-war opposite 'the Parks', now a library; Taken from Market Deeping Bridge.

First published 2012

Amberley Publishing
The Hill, Stroud
Gloucestershire, GL5 4EP

www.amberley-books.com

Copyright © Dorothea Price, 2012

The right of Dorothea Price to be identified as the Author of this work has been asserted in accordance with the Copyrights, Designs and Patents Act 1988.

ISBN 978 1 4456 0331 5

British Library Cataloguing in Publication Data.
A catalogue record for this book is available from the British Library.

Typeset in 9.5pt on 12pt Celeste.
Typesetting by Amberley Publishing.
Printed in the UK.

# Contents

# Introduction

*To my daughter, Elizabeth, who has spent many happy hours
boating on 'our stretch' of the Welland*

The River Welland has been a main waterway through South Lincolnshire for centuries, slowing through Stamford, Market Deeping, Deeping St James, Crowland, Spalding and finally out to sea at Fosdyke.

This book is concerned principally with the role the Welland has played as it flows through the Deepings, historically prior to the Canal Age, then in the heyday of river commerce in the seventeenth and eighteenth centuries when the section between Stamford and Deeping St James was canalised, and lastly the role the river has played in more recent times.

A version of this book was first published quite a few years ago and therefore I have taken this opportunity in the new edition to include more photographs and some additional text and captions.

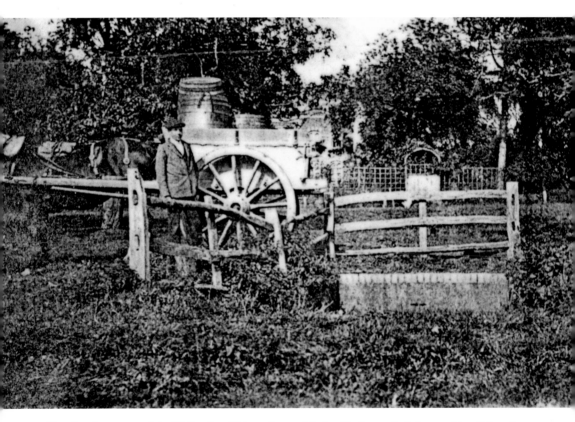

Showing the source of the Welland at Sibbertoft near Market Harborough, Leicestershire. Taken from the Natural History Society and Field Club Journal September 1921. Date of photograph 1914.

As this book deals mainly with the River Welland and its many aspects between Spalding, the Deepings and Stamford, I think therefore that for the benefit of readers who are unfamiliar with the Welland area mention must be made of its 72.5 mile course.

According to the 1727 edition of Peck's *Annals of Stamford* the source of the Welland began in the grounds of the Old Vicarage at Sibbertoft, near Market Harborough, Leicestershire. However, during the 1990s we travelled to Sibbertoft and saw where the Old Vicarage once stood. On meeting the lady who now lives in a new property in the grounds we were taken to where there was a trickle of water. On the opposite side of the road was the sign 'Welland Rise'.

Some three or four years ago, Julia Bradbury of the BBC's *Countryfile* programme came across several other rivulets so we must assume the Welland has more than one source.

Thankfully, after the disasterous flood of 1947, several new cuts and diversions have been made on the Welland, namely the Maxey cut and Coronation Channel near Spalding, thus alleviating the danger of a flood of that scale happening again.

# Acknowledgements

My sincere thanks to Mr Jim Blessett for his help, advice and encouragement.

Also to my husband for taking many of my photographs and especially for walking the riverbanks in search of the watermills and parts of the old canal.

*Stamford, An Industrial History*, N. C. Birch
*Spalding, An Industrial History*, Neil Wright
*Stamford Mercury*
*Peterborough Evening Telegraph*
*Lincs. Spalding Free Press*
*Illustrated London News*
*Lincolnshire: A County of Infinite Charm*, Arthur Mee
Baytree Garden Centre
Mr Gerry Lewis

*Photographs*
Most of the photographs were taken from my own collection with additional material loaned to me by Mr Mike Crowson, Mr W. A. Crowson, Mrs Nancy Titman, Mrs Edie Merrill, Mrs Sheila Hampshire, Mrs Virginia Hall, Mr John Uylatt, Mr & Mrs N. Phillips, Mr David Willson.

# 1

# Waldram Hall

*Waldram Hall – Welland, navigable from the sea to Stamford – Park House – Low Locks – Boat House – High Locks – Market Deeping*

## Waldram Hall – *Where's That?*

Ask someone who has lived in the Deepings if they have heard of Waldram Hall and the chances are they will say 'no'. However, the records I have show that Waldram Hall dates back at least to the thirteenth century and was, for many centuries, an important crossing on the Welland.

In fact, it was situated at the far eastern end of the village, almost on the Peakirk border.

The 1772 2nd Edition of Dugdale's *Imbanking and Draining of the Fens* states that the Fenland district comes to within a few yards of it, and it is clearly marked in more than one of the maps of this work.

John Clare's poem 'The Fens' portrays this part of the Welland and I quote three verses below:

Wandering by the river's edge,
I love to rustle through the sedge
And through the woods of reed to tear
Almost as high as bushes are.
Yet, turning quick with shudder chill,
As danger ever does from ill,
Fear's moment-ague quakes the blood,
While plop the snake coils in the flood.

And hissing, with a forked tongue,
Across the river winds along.
In coat of orange, green and blue
Now a willow branch I view,
Grey waving to the sunny gleam,
Kingfishers watch the ripple stream
For little fish that nimble by
And in the gravel shallows lie.

Eddies run before the boats,
Gurgling where the fisher floats,
Who takes advantage of the gale
And hoists his handkerchief for sail
An osier twigs that form a mast And
quick his nutshell hurries past,
While idly lies, nor wanted more,
The spirit that pushed him on before.

In the *History of the Fens of South Lincolnshire*, 2nd Edition of 1896, W. H. Wheeler tells us that there was a ferry here for passengers going to and from Crowland and that in 1330 the toll was fixed by the Abbot at one penny for inhabitants and double to strangers. A treble charge was allowed in stormy and tempestuous weather.

The *Place names of Northants*, edited by Stenton in 1933, cites the following versions of the name:

Alum Waldrund (1275)
Walrondeshalle (1350)
Walroom Hall (1753)

Stenton says it takes its name from the family of Waleran, son of Ralf of Helpston, of whom there is a record in 1177–1189.

The *Victoria County History of Northants*, volume 2, published in 1906, says that Walderham Hall is a dilapidated farmhouse on the right bank of the River Welland. It is mentioned in the latter part of the thirteenth century and frequently afterwards. In the time of Henry VIII, £4 was paid to the Bailiff of the Manor of Maxey by Nicholas Baxter as rent for Walderham Hall, also 5/- for the crossing of travellers with merchandise from the country to the market of Deeping with carts and horses. The hall was granted by Edward VI with toll and fishery to David Vincent for twenty-one years, and in fee to Sir William Cecil in 1561 by Queen Elizabeth. It now, in 1906, belongs to the Fitzwilliam family.

The Fitzwilliam Charter at the Northamptonshire Record Office contains the following references:

(a) A Defeansance of Bond in 1398 refers to a message in Estdepying called Walranhalle.
(b) Conveyances and leases of land in Waldram Park were made in 1504, 1517, 1525, 1566 and 1571.
(c) A Memorandum in Particular of Manor of Maxey (dating from the time of Edward VI) states:

... that the farme of Waldranhall is an Inne and sometime greatly frequented by Pilgrymes passing to Walsingham, and then let out for £VIII a yeare and now lett but for 40l- by the discretion of those that were the kinges Officers.

In the Fitzwilliam Correspondence the following letters were written by Lord Fitzwilliam to his steward Francis Guyton (suggesting that the house needed rebuilding):

(a) *dated 4.4.1706 Ref; NR.a. F (M) C 1472*

If you have gott all your materialls together both stone and timber, you may begin ye Buildirig at Waldram Hall when you will, for it is now fine weather.

(b) *dated 11.4.1706 Ref; NR.a. F (M) C 1476*

For Waldram Hall house you may go about that, as soon as you can, because you say you have laied in ye stone and mort-arr already. Do not overdoe the Worke by building a Bigger and better house, than is necessary for the tenant, but what you do, lett it be done strong and well.

(c) *dated 20.6.1706 Ref; NR.a. F (M) C 1496*

If Waldram Hall can stand another years I am not against it, but feare of the worst, however if the waies be very good now, you would do well to caJ;'ry all the stone, mortar and timber that you shall want for the worke that it may be ready to begin early in the yeare.

The house is not mentioned by name in Whellan's Directories of 1849 and 1874, but buildings are shown on the site as recently as the OS Map of 1952.

The drawings of Waldram Hall in 1714 show the immediate site of the Hall in relation to the Welland and the Borough Fen Dyke (N.R.O. Ref; Fitz. Misc. Vol. 99).

Waldram Hall was in the Parish of Maxey, and writing in 1892 the Revd W. D. Sweeting MA in the Register of Maxey 1538–1713 says that WALTRAM HALL (Reg. Bur., 1550), now called Waldram Hall, is a small decayed farmhouse at the extreme end of the parish, four miles from the Church of Maxey.

He records the following marriages:

Nov 8 1560 Robert Mell and Agnis Deeping of Waterhom hall.
June 10 1666 William Hicklin and Bridget Smith. [Hicklings were associated with Waldram
    Hall for many centuries].
Sept 15 1668 Matthew Hicklin and Grace Sansome.
Sept 28 1696 Daniel Rowell of Croyland and Elizabeth Hicklin [Hicklyn].

And burials:

Mar 14 1550 Wm s. of Jo Deeping of Waltr' hall.
June 14 1552 Godfrey s. of Jo Deeping of Waterh'hall.
April 2 1553 John Deping Waterhom hall.
Nov 24 1560 Nich'as Deping of Waterhom hall.

Although Sweeting said it was 'decayed' in 1892 and the V. C. H. describes it as 'dilapidated' in 1906, it clearly was not as the following notes were given to me by Mrs Edie Merrill, who lived there during her childhood in the 1920s. I quote her as follows:

Waldram Hall was our home in the 1920s. It was a lovely old stone built farmhouse with a red pantile roof.

As you went through the front door there were staircases which went left and right and led to the bedrooms, there were three in the front of the house and two at the back. All of these rooms had stone floors.

On the ground floor there was a large living room and an equally large pantry. Also on the ground floor was a typical farmhouse kitchen with an open fireplace, with two large ovens, and from the fireplace hung a large iron cooking pot, this was suspended on a chain.

To the rear of the house was the farmyard, with a large orchard and garden.

With the river running past the front of the house, it was a delight to play, picnic, paddle and fish for 'tiddlers' here during the school holidays. I particularly remember sitting fishing with my home made rod and safety pin – but never catching anything – with Mr Fred Popple, a well-known Deeping resident and an expert angler.

But in the winter months it could sometimes be very difficult to get to the village school in Glinton, especially if there had been a lot of rain or a heavy fall of snow.

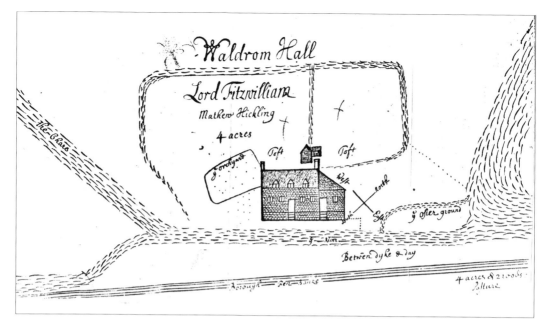

From a survey of the Lordship of Maxey for Lord Fitzwilliam dated 1714. Waldrum Hall, owner Lord Fitzwilliam, Tenant Matthew Hickling.

Pack Horse Bridge near Waldram Hall, 1992.

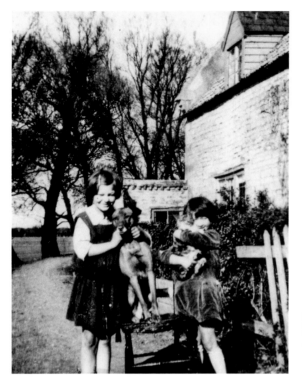
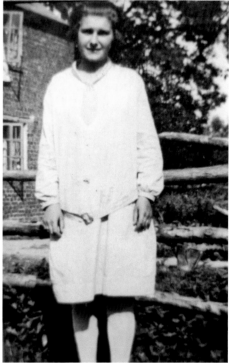

*Above left:* 1920s: Mrs Edie Merrill on the left at Waldram Hall.

*Above right:* Miss Elizabeth Morris at her home, Park House on the approach to Waldram Hall.

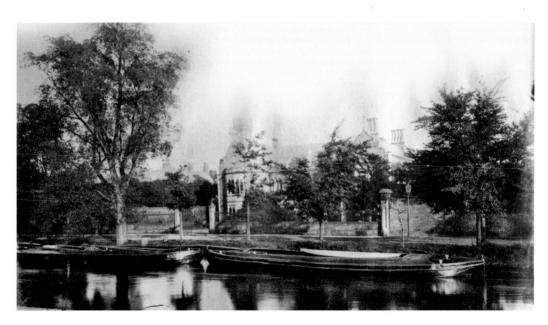

A Fenland lighter moored on the Welland in front of Ayscoughfee Hall, and no doubt this would have been the type of lighter which would travel along the Welland into the Deepings and on to Stamford.

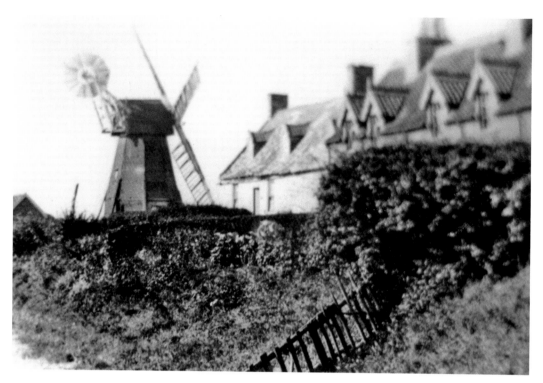

Locks Mill and cottages.

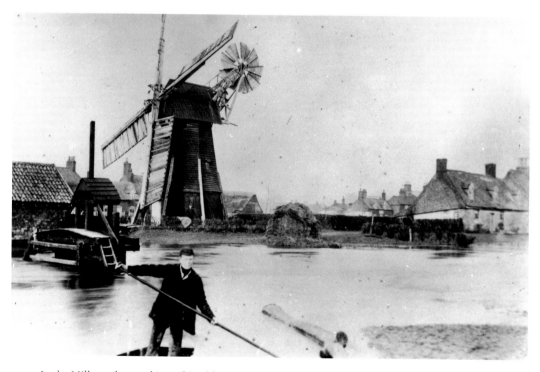

Locks Mill, on the outskirts of Spalding around the early 1900s.

It is probable that Waldram Hall lost much of its importance when the stone bridge was built in Deeping St James in 1651, but it remained as a large farm until very recent times.

However, just a few weeks ago I was told that the Hall was still standing in 1936, after which time it began to deteriorate and in the 1940s it was demolished, although some outbuildings were still evident in the 1950s. It has also been said that some of the building stone was brought into Market Deeping for building purposes.

Sadly, today the only visible signs of Waldram Hall are the odd large stones lying just above ground level, with a hint of buried foundations.

However, we recently visited the site and discovered a small packhorse-type bridge which crosses a dyke and links two grass paddocks. It is constructed of small red bricks – which could well have been handmade – with the base of it being built with about six courses of long thin stone.

In the Fitzwilliam Charter at the Northamptonshire Record Office it states 'that the farme of Waldramhall is an Inne and sometime greatly frequented by Pilgrymes passing to Walsingham...'

Obviously their journey would have taken them via the river banks, this being the most direct route, so it is possible that this bridge, which lines up very well with the river bank over the railway line – there were no railways in those days – was used by the pilgrims making their way to Waldram Hall and the ferry crossing, where they would then continue on their journey to the next resting place at Crowland.

## Welland, Navigable from the Sea To Stamford

The first Act of Parliament authorising improvements to the River Welland from Spalding to Stamford was in 1571, during the reign of Elizabeth I, to make the River Welland navigable from Stamford to the sea forever. In fact, the construction work and improvements did not take place until 1620, when at meetings of the commissioners of sewers, held at Stamford on 26 August and 10 September, it was decreed by James I that the Act be confirmed, and a new cut be made.

This new cut rejoined the river some nine-and-a-half miles downriver at the lock at East Deeping. Mainly constructed by the linking and widening of existing drainage ditches, it was built entirely at the expense of the aldermen and burgesses of Stamford. There were twelve locks in all within the nine-and-a-half miles, with each measuring 60 feet long and 12 feet wide; these locks enabled vessels of 7-foot beam to gain access to the town.

The commissioners decreed that the toll would be, 'at every lock they shall go though, the sum of threepence for and upon the ton'. The owners of the navigation were also empowered to charge wharfage fees.

In 1633, the navigation and the tolls arising from it were leased to Daniel Wigmore, one of the aldermen, for eighty years at twelve pence a year, a further lease was granted to Wigmore's representative Charles Halford on payment of £100.

An interesting report in the *Stamford Mercury* of 18 July 1821 relating to the River Welland stated that 'the navigation will be laid dry during the first week of August for repairs of Locks between Deeping St James and Stamford'. The lease continued in private hands until around 1830.

In April 1863, the navigation was used for the last time as, apparently, lessees of the canal had not kept it in repair and water in the new cut escaped into the old river. All of the locks required repair and it became impossible for the boats to navigate. By April 1865, it was decided to sell the canal by auction. This took place at the Town Hall in Stamford, with 23 lots being offered for sale.

Lots 22 and 23 were the only two relevant to the Deepings, with Lot 22 offering 'All that Piece of Land lying between the River Welland and the Lower Locks in the Parish of Deeping St James together with the Lower Lock Pen and gates'. Lot 23 offered 'All that Lock Pen and Gates known as 'Briggin Lock' in Deeping St James nearly opposite the Crown and Anchor'.

There are still a few remaining traces of the canal to be seen today along various parts of the river bank.

## Park House

And so to retrace our steps and return to Waldram Hall. There was only one other property in this area and it too was a large, old, stone-built farmhouse known as Park House (it is clearly seen on the 1900 Edition OS Map).

The photograph on p. 10 shows Miss Elizabeth Morris outside Park House, which was her home in the 1920s.

Here there were numerous outbuildings and stables and no doubt it would be possible for the lightermen to obtain stabling accommodation with perhaps a change of horses after the ride from Spalding and Crowland, reputed to be the loneliest part of the journey, and for this there would probably be three or four lighters in a string being towed by two large shire horses.

It was here that the fenland lighters, travelling from Spalding and Crowland, would actually begin their journey into the Deepings, carrying goods such as coal, groceries, deals, pitch and tar from our own North Sea ports as well as the Baltic ports, on large sea-going keels and schooners, making their berths at the numerous riverside quays in Spalding, with some of their cargo being transferred onto the small inland lighters, these then making their way into the Deepings and finally onto the long and sometimes arduous journey to the wharves at Stamford.

So now, having left Waldram Hall and the Park House area, the Welland bridge comes into sight. This was built to carry the London and North Eastern Railway line from Peterborough to Spalding across the river, and it was the building of the railways that saw the subsequent decline in river traffic.

Before moving away from this area, a mention ought to be made about the large lake – almost a mile in length – which we see just before the bridge (this is not to be confused with the 'Mere'). Locally this has always been known as the Ballast Pits, and in 1848 a gravel pit and brickworks was established to produce about two million bricks for the GNR.

At that time about 100 men were employed in making bricks at these gravel pits and brickworks, with a temporary settlement being constructed, which took the form of brick and slated houses and cottages, blacksmiths' and carpenters' shops, engine houses and stables and various other sheds.

In the 1871 Deeping St James Census, this part of the village was listed as the 'Ballast Hole'.

## Low Locks

And so the journey now carries on to the Low Locks in Deeping St James. The scene would look very much different to the lightermen in those far off days, especially in lower Eastgate. There would be no riverside houses and gardens as we see them today; instead, in the main, there would be osier beds (these belonged to the farmhouses on the opposite side of the road). The willows would be cropped regularly, tied into bundles and then carefully stacked by the side of the road to await transport to one of the nearby market towns, where they would be delivered to a basket maker who would eventually prepare the willow canes and fashion them into various kinds of baskets. Some of the thicker willow canes would be used for making into thatching pegs. These would prove very useful, as not only were there numerous thatched cottages in the village at the turn of the century, but there would also be corn stacks which had to be thatched to keep out the winter weather. There were still one or two osier beds in use during the 1930s, but after the War the demand for these grew less and less and, after the serious flood in 1947, and the eventual building of the Maxey cut – designed to take all the surplus river water away from the village – the osier beds began to dry out, which in turn enabled the present-day gardens and lawns to be created.

Welland Bridge with a diesel 'Sprinter' travelling to Spalding.

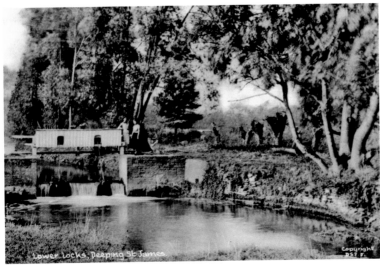

Lower Locks, Deeping St James.

Copyright DSJ P.

The main river, original lock and lock pen, 1915.

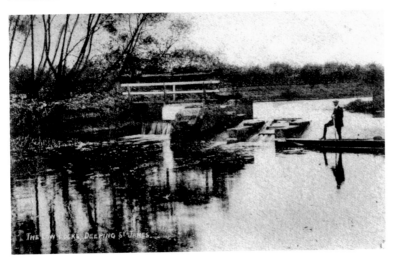

THE LOW LOCKS, DEEPING St JAMES.

Low Locks *c.* 1910 – note the 'wash stones' and boat rollers. This part of the river is diverted around a small island known as 'Scout Island', before rejoining the main river after the old lock pen.

Approaching Low Locks, 1960s.

The same view, 1970s.

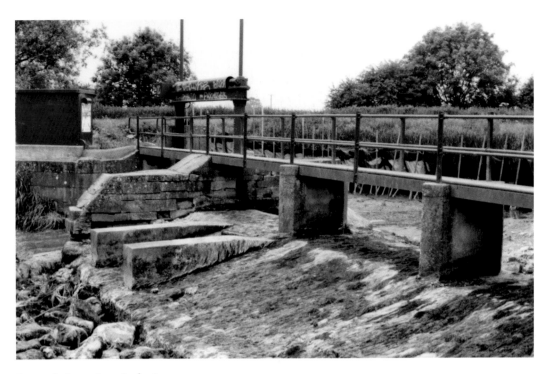

Decayed piers at Low Locks, June 1994.

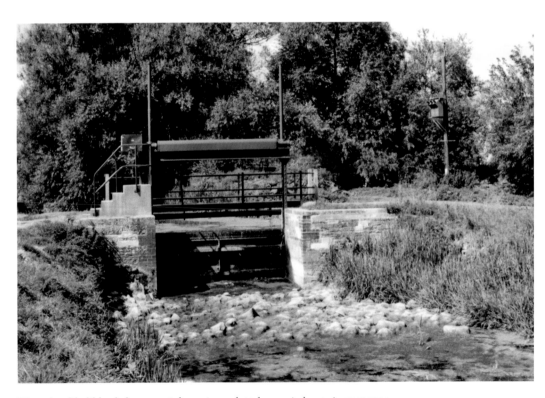

Water level held back for essential repair work to be carried out, August 1994.

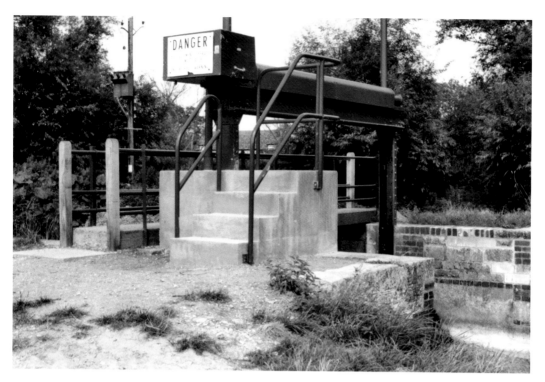

Repair work underway, August 1994.

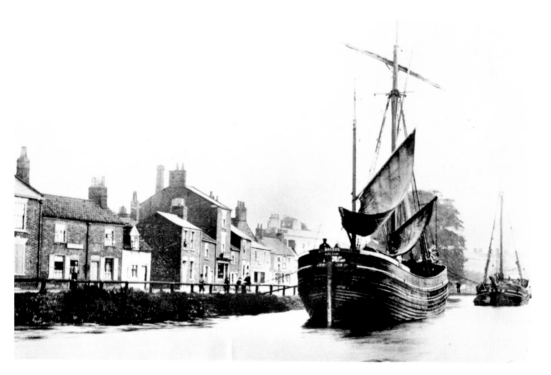

Humber keel *Breeze* returning empty to the Humber after its coal-carrying run to Spalding, 1900.

This is where the Locks Mill used to stand. Picture taken *c.* 1990.

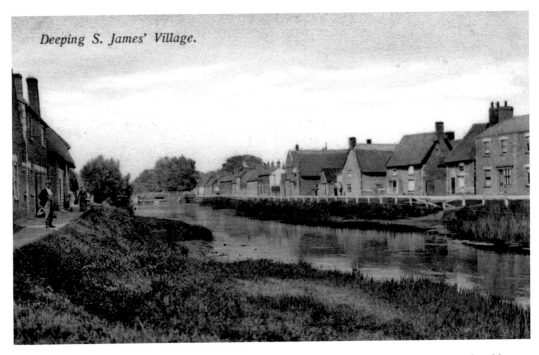

*Deeping S. James' Village.*

Deeping St James with part of Deeping Gate on the left and High Locks in the distance. Note the old thatched cottages on the right.

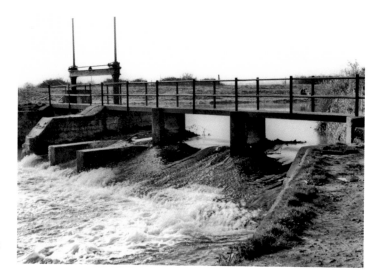

1970: The new footbridge over the 'wash stones' with the new lock gate on the left.

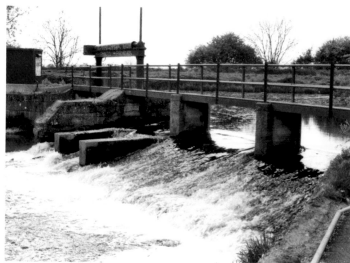

April 1994: Over the wash stones at Low Locks.

Tarpaulin barriers in use to divert the main flow of water over the wash stones, May 1994.

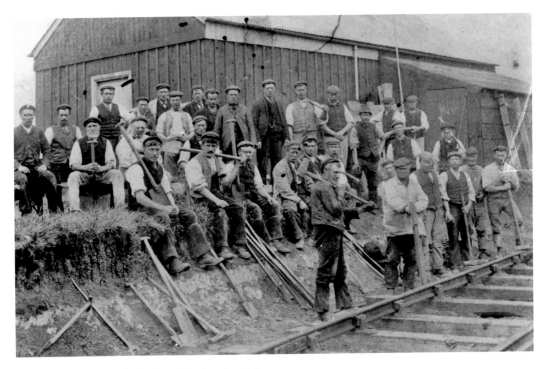

Local men working at the ballast pits, Deeping St James, *c.* 1900.

Ballast pits *c.* 1980 over Deeping St James railway station.

At one time water lilies and large water marigolds grew in patches along this part of the river, and I think to quote John Clare's poem 'The Welland' would be very appropriate at this point of our river journey.

> There's something quite refreshing to behold
> A broad and winding river wirl away
> Here waterlilies studding nooks with gold
> There yielding rushes bowing gently curves delay
> The waters for a moment – till they pass
> And in a stiller motion sweep and bend
> A broad and liquid mirror smooth as glass
> In whose clear bosom are distinctly penned
> Trees flowers and weeds in a delightful mass
> Like happy thoughts in quiet's easy mood
> O'er which the fisher prows his boat along
> And welland on thy reedy banks I find
> Calm musings too I'm fain to cherish long.

Now we reach the Low Locks, where traces of the old Lock Pen can still be seen. It was here that the water level would be adjusted to allow the lighters to pass through to the main river.

## Boat House

Having negotiated the Low Locks, the next stopping place would be the Boat House – almost adjacent to the Cross – and this is where the lighters would unload their cargoes, consisting mainly of fleeces and corn, with perhaps a small variety of household commodities.

In the days of river traffic, though, it would have looked very much different. The end facing the river was completely open to the water with a slipway going right underneath the building to allow the lighters to gain access to the upper floor. This floor was reached by means of a large trapdoor, and it was through this that the cargo would be hoisted up to the storage area above.

Perhaps goods would also be loaded onto the lighters from here to be taken further upstream to the jetties in Market Deeping before going onto Stamford.

The external access to the Boat House was, and still is, by means of a very stout wooden ladder on the end of the building facing the Cross.

Happily today, the Boat House, built of the familiar Barnack Rag stone and complimented with a Collyweston slate roof, is a Grade II listed building.

After travelling a short distance upriver it has been said that another resting place for the lightermen and their horses was at the house and barn which stood almost at the foot of the river bank (this has been demolished in recent years) with the uppermost storey of the house being used as a lookout for lighters coming up river.

A little further on from here, there were two small cottages by the side of the river (now one house). At one time my great uncle – Mr Buck – lived in one of the cottages, and it was he who took the last lighter upriver to Stamford.

Next door to these cottages another riverside house, which still stands today, was also a favourite stopping place for the lightermen; at that time it was a beer house or tavern known as the 'Laburnam Arms'.

And almost opposite here, a beautiful old property would have been seen from the river. This was 'The Manor', once the home of the Dowager Marchioness of Exeter. Previously it had been known as 'Deeping Waterton Hall', when it was then owned and occupied by Mr Waterton. The Manor was demolished in the 1970s.

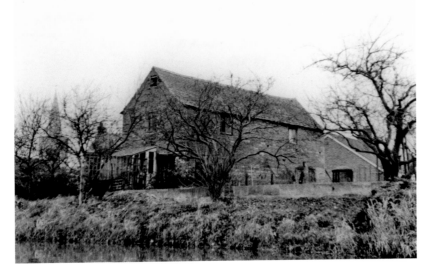

The boat house as seen from the river in 1970, used for unloading barges in the days of river traffic.

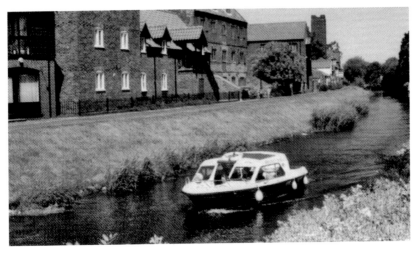

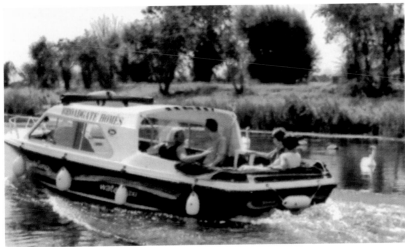

*Middle and bottom:* Spalding water taxi on the River Welland.

The tall house in the centre of the picture, 1970, was always thought to have been a 'look-out' for lighters on the river.

The homes of Mr Spooneer and Mr Geo Buck, my great uncle, 1971, who took the last lighter up to Stamford.

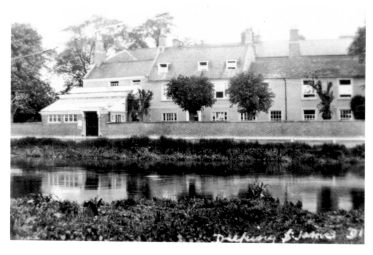

Lightermen would have passed this impressive building just before the bridge – 'the Manor', 1920s.

The bridge would then come into sight and, up until the 1920s, parts of the old towpath could still be seen along the roadside, and immediately under the bridge on the Deeping Gate side stood a long building which is said to have been where the lighters were repaired.

Along Bridge Street, just before the High Locks, the seventeenth-century Oriel window can still be seen – this too was used as a lookout for lighters travelling along the river, and I remember Miss Day (the author of *History of the Deepings*) telling me that some of her ancestors not only owned but also used to repair lighters in the yard at the rear of the house.

## High Locks

And so onto the High Locks, where until recent years the old wooden lock gates could still be seen. We can see, however, a fairly good example of a Lock Pen – which has unfortunately over the years seen quite a lot of damage through one source or another – this ought to be repaired before it loses its identity altogether. However, this was known as 'Briggin's Lock' in Bridgate, not Bridge Street as we know it today.

Beyond the High Locks and adjacent to Bridge Street is the 'Meadow House' – the last house on the riverside, where years ago was a ford crossing. Traces of the old towpath can still be seen here.

## Market Deeping

We are now approaching Market Deeping, the last stage of our river journey, and here the principal barge owners were:

Mr John Perkins, who lived at Welby House in High Street. He was also renowned for his flocks of geese; the quills from the geese were plucked at a certain time and were used in the making of quill pens for the Bank of England.

Mr Joseph Mawby, also a prominent business man in the town; it was he who had the then 'New Inn' (now the 'Deeping Stage') built in the Market Place in 1802.

Mr William Laxton.

There were landing stages and jetties to the side of the then 'New Inn' which led out on to the main street, where workmen would be awaiting the arrival of the lighters, and once their cargoes were unloaded the goods would be taken by horses and carts to the numerous warehouses in Market Deeping, these being owned by the wealthy merchants of the town.

The old wooden bridge at Market Deeping stood to the side of the Inn and the last of the warehouses and jetties were on the Stamford Road. These at one time belonged to the Needham family. Although some have undergone alterations in recent years, the buildings by the side of the river have remained unused for some considerable time, but both can still be seen today.

Some time in the eighteenth century or possibly earlier there was a canal dug along the north side of the Welland and close to it and parallel which was used by barges connecting the Fens with Stamford and beyond.

Market Deeping's prosperity and development was based on the fact that it was a port used for collecting grain from the Fens and distributing it and no doubt bringing in wool from the Cotswolds wool belt and distributing that in the district.

A number of prosperous merchants lived there including the Perkins family who occupied the famous Canal Dock House and carried out a prosperous business for many years, which only came to an end with the advent of the railways. The canal became disused, finally weeding up.

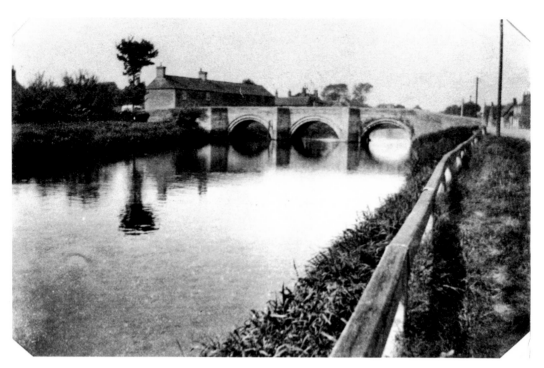

1920s bridge and barge repair workshop. Note the old river railings, removed after the 1947 flood.

This oriel window before the High Locks would be used as a lookout for lighters on the river.

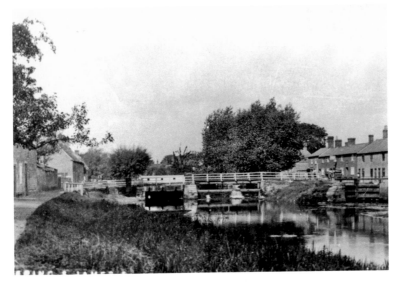

High Locks, Deeping
St James, *c.* 1910.
The lock pen is seen
on the right.

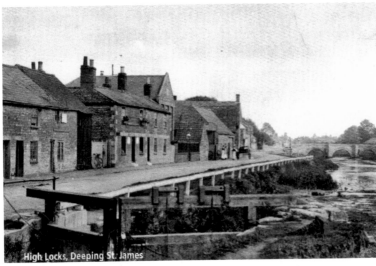

A good view of the
lock pen, 1920s.

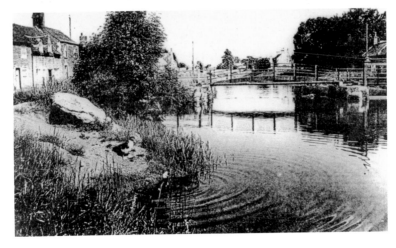

Once through the
locks, lightermen
would tie up at
this boulder to
make their way
to the Crown or
Anchor across the
road. Sadly, neither
remains today.

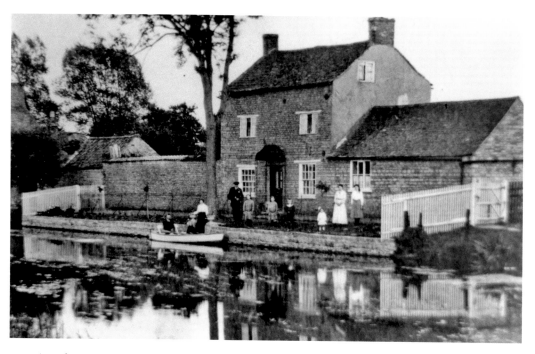

'Meadow House' on the Deeping Gate side of the river and the last house before reaching Market Deeping.

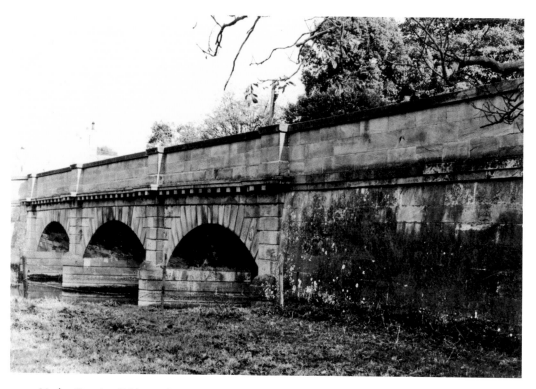

Market Deeping Bridge, 1960.

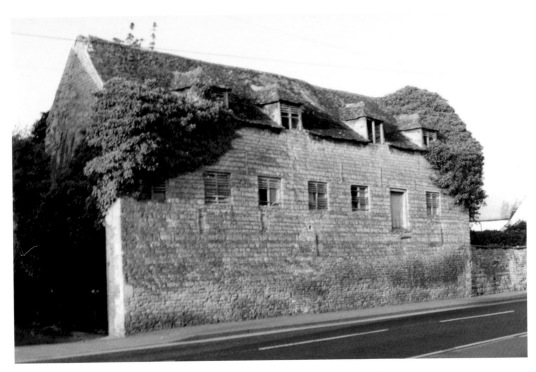

Former warehouse on Stamford Road, Market Deeping, in 2010, now tastefully restored.

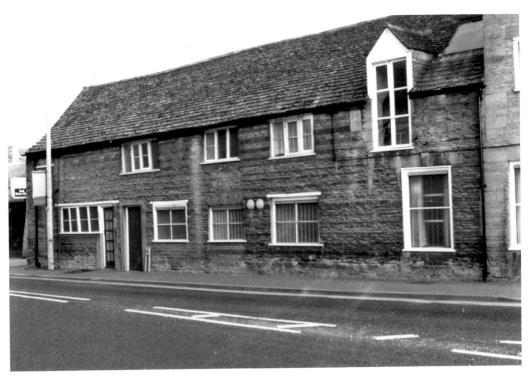

Old warehouses at Market Deeping, now restored, 1992.

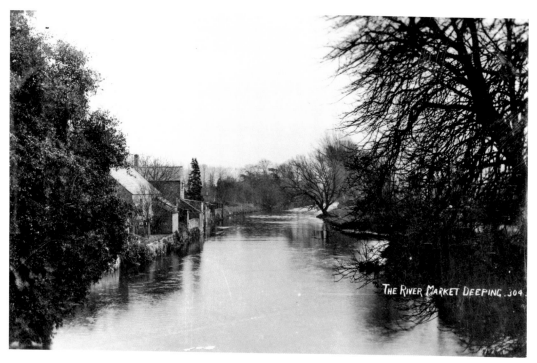

From Market Deeping Bridge looking downstream, 1920.

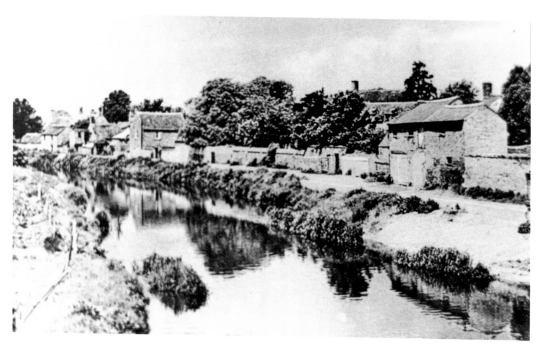

Picturesque cottages by the riverside at Market Deeping, *c.* 1950.

# Watermills on the Welland

*Thorpe's Mill – Molecey Mill – Maxey Mill – West Deeping Mill – Lolham Mill –*
*Tallington Mill – Hudd's Mill – King's Mill*

In all there were eight watermills on the Welland between Market Deeping and Stamford – covering a distance of roughly 8 miles.

### Thorpe's Mill

The first watermill on the Stamford Road was Thorpe's Mill. It had remained a working mill until the early part of this century when, in the 1930s, the mill itself was demolished with only the mill house remaining.

The following information was taken from the Archives of the Museum of Lincolnshire Life – Lincoln.

> *Stamford Mercury 19 November 1824* Mr Thorpe's mill at Deeping St James [would mean Market Deeping] – man fell into lock on 13 November 1824 when returning from Bull baiting [in Stamford].

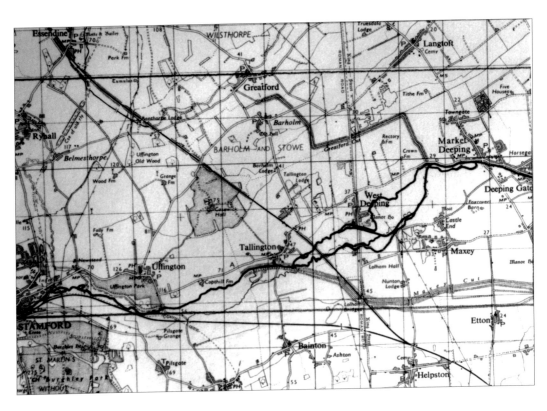

Looking towards Thorpe's Mill, 1920s. The old towpath is seen on the right.

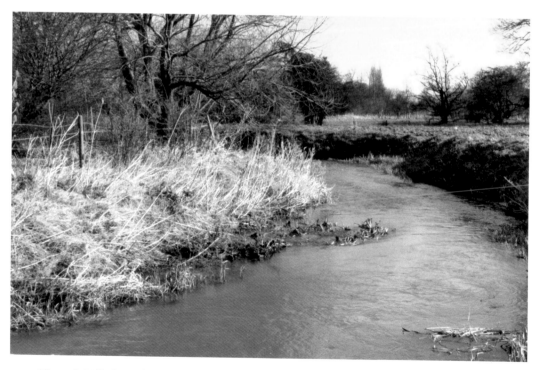

Thorpe's Mill, the Welland bypass above the mill, 1990.

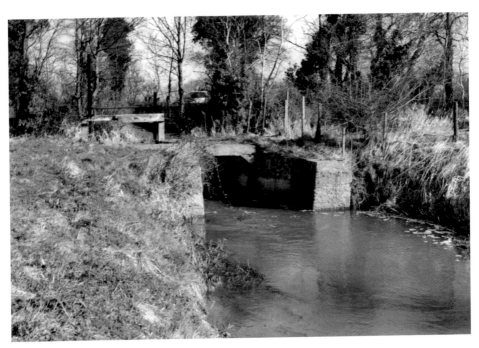

Thorpe's Mill, the relief channel, 1990. This would have controlled the water into the mill.

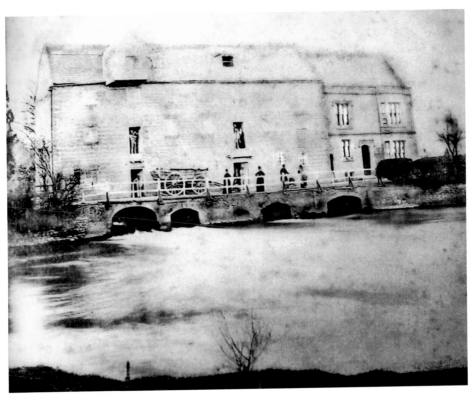

Showing members of the family posing for the photographer, Thorpe's Mill, 1880.

*Stamford Mercury 6 August 1883* Wanted – a general miller – water power – apply to Mr J. Thorp Market Deeping Mills.

*The Miller Magazine 16th April 1894* Wanted in a Roller Mill, one who understands Robinson & Sons system preferred. Apply John Thorpe, Market Deeping Mills.

*Grid Ref 133099* This mill does not appear on the OS of 1824. It stood at the West of the village on the south side of the main road, just short of the turning that goes to Towngate. It was worked by the River Welland and is shown on the 1906 but not on the 1963.

Millers

| | | |
|---|---|---|
| 1842 | John Thorpe | West Deeping |
| 1849 | John Thorpe | Stamford Road |
| 1855 | John Thorpe | Stamford Road |
| 1861 | John Thorpe | Stamford Road |
| 1868 | John Thorpe | Stamford Road |
| 1872 | John Thorpe | Stamford Road |
| 1882 | John Thorpe | Mill Lane |
| 1889 | John Thorpe | Mill Lane |
| 1892 | John Thorpe | Mill Lane |
| 1896 | John Thorpe | Mill Lane |
| 1900 | John Thorpe Ltd and Steam | |
| 1905 | John Thorpe Ltd and Steam | |
| 1916 | John Thorpe | Stamford Road |
| 1917 | John Thorpe | Mill Lane |

## Molecey Mill

The second watermill on the Stamford Road is Molecey Mill, dating to around 1773. It is reputed that a mill house has always been on the site since the tenth century, and it was of the type in which the mill was built over the wheel, this being iron hybrid and 'undershot'.

The following information was taken from the Archives of the Museum of Lincolnshire – Lincoln.

*London Gazette 2–6 December 1800*

Whitehall December 6th 1800. Whereas is has been humble represented to the King that several anonymous threatening letters of which the following are copies have been sent to Mr William Billey of Alwalton and Mr Yilliam Hardwick, and Messrs J. and W. Ricketts of Lolham Mills in the County of Northampton, Viz:

Mr Hardwick – Miller – Deeping.

Sir,

If you don't fall your flower next Saturday to 3/6d per stone we will put your mill down over your head and take your flower away. We will Dragg you a Bout the Markett place on Saturday next.

*SURVEYS: 1824, 1827–8, 1835, 1906*

Millers

| | | |
|---|---|---|
| 1826 | John Thorpe and Son | Halfleet |
| 1835 | John Thorpe and Son | Deeping Mill |
| 1842 | John Thorpe and Son | |
| 1855 | James Greaves | Mkt Deeping Millstones |
| 1861 | John Bellairs | |
| 1868 | Herbert Twigge Molesey | |

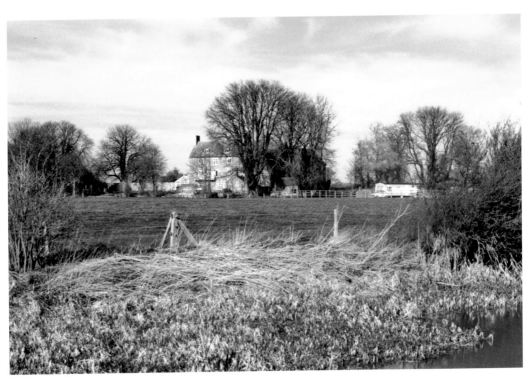

Approaching Molecey Mill, 1990.

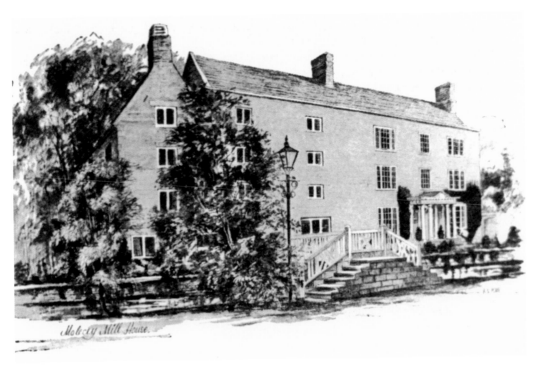

Molecey Mill House.

A delightful 1920s sketch of Molecey Mill and Mill House. The mill is seen just behind the tree.

On speaking to Mr R. Witt, he told me that his grandfather and grandmother came to Molecey Mill in 1896.

It was then bought by his father and mother on their return from America, where they remained until around 1949.

## Maxey Mill

The next watermill is the last working watermill on the Welland and dates from 1779. It was built by John Molecey, who owned the Fullard's Mill a little further downstream beside the Deeping–Stamford Road.

This is the third mill to be built on this site – the first dating to around 1203 – and replacing one which had been destroyed by fire.

It houses two pairs of stones – one pair being Garnet Carborundums – this is a thickness of cement with grains of carborundum set into the grinding surface. The second pair are the very hard Derby peaks.

In the days of traditional milling, and when corn was always taken to the local mill for grinding, one sixteenth of the end product would be retained by the miller.

Around 1809, the mill was regularly visited by John Clare, the Helpston poet, who at that time was horse-boy for the landlord of the 'Blue Bell' at Helpston and was sent to the mill each week to fetch flour.

In his poem 'The Fall of the Year', he had this to say regarding the mill:

The Summers voice is still
Save for the clacking of the mill
And the lowly-muttered
thunder of the flood...

The present owner of the mill is Mr D. Stables, and on average he grinds 30 tons of grist per week, which is used to feed the many pigs on his farm.

The mill is built with local stone and topped with a Collyweston slate roof, and in 1985 Mr Stables and the contractor responsible for the restoration work carried out at the mill received a Civic Trust Award.

An item of interest regarding the parish of Maxey reads as follows:

Maxey means 'Maccus's Island' and this is thought to have been originally an island between the two arms of the River Welland, the area which is represented by the modern parishes of Maxey, Deeping Gate and Northborough. The now-extinct arm [south] of the Welland was replaced at the enclosure of 1809–20 by the North Drain [now the Maxey Cut] and the South Drain.

Millers

| 1901 | Isaac Loweth | Miller |
| 1917 | E. Loweth | Miller and Farmer |
| 1917 | Isaac Loweth | Miller |

I am indebted to Mr Stables for allowing me to take the series of photographs at his mill which are shown following:

Approaching Maxey Mill, 1990.

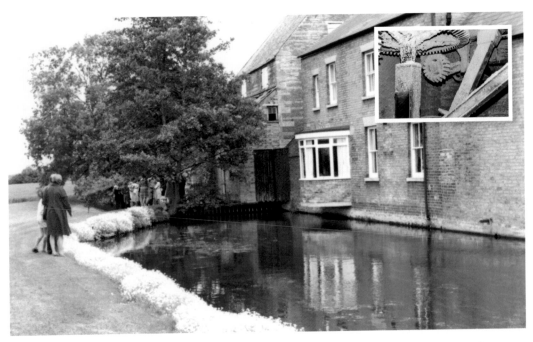

Maxey Mill, 1979. The rear of Maxey Mill, the miller's house, a mill stream. This photograph was taken 'on an open day'.

*Inset:* January 1990, Maxey Mill. This photograph shows the spur wheel on the ground floor. It is a wooden wheel and toothed in Beech wood. The small hole seen off-centre of the speer wheel is the home of the resident mouse who often takes a ride on the speer wheel.

Maxey Mill, 1990, showing the River Welland coming into the mill.

This photograph was taken from Maxey Mill going towards Lolham Mill and West Deeping.

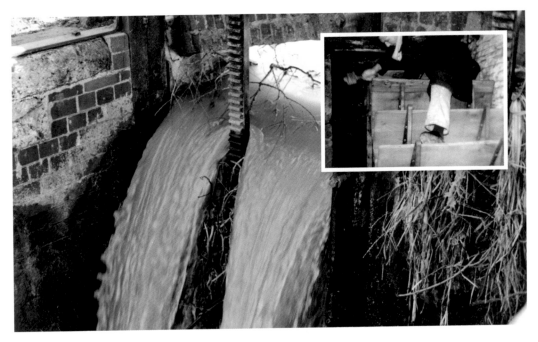

The outflow from Maxey Mill, 1990.

*Inset:* A new paddle wheel being fitted at Maxey Mill in 1953. This is a breast shot wheel, 13 ft diameter, 3 ft 6 in broad, and it carries thirty-six paddles.

## Lolham Mill

The first mill on this site was dated 1640 and the present house is dated 1810. The mill itself was burned down in the 1860s.

The Mill is in Lincolnshire, but Lolham is a hamlet just over the Northants border and stands on the River Welland.

All of the following information was taken from the Archives at the Museum of Lincolnshire Life – Lincoln.

*Stamford Mercury 29 November 1805* On Thursday night the 21st inst died aged 60 years Mr Ricketts of Lolham Mills Nr Market Deeping.

*Stamford Mercury 8 August 1817* Wanted: A journeyman miller – Apply to Wm Ricketts Lolham Mills Market Deeping.

*Stamford Mercury 8 March 1839* Mr Ricketts Lolham Mills Nr Deeping advertising a house and bakehouse in Stilton.

*Stamford Mercury 16 August 1839* Wanted at Michaelmas – an experienced workman and good stone dresser – apply Mr Ricketts Lolham Mills Nr Market Deeping.

*Stamford Mercury 25 September 1840* Died on Monday last in his 72nd year Mr Rickett an eminent miller of Lolham Mills Nr Market Deeping.

*Stamford Mercury 15 October 1841* Wanted – a good hand to take the management of a watermill – apply to Messrs Samuel and Edward Cross Lolham Mills Market Deeping.

*London Gazette 18 March 1895* Wm Rickett – Lolham Nr Deeping Lincolnshire, Miller, named in a list of creditors of John Bradshaw, late of Leicester, Baker, prisoner for debt in the Fleet prison.

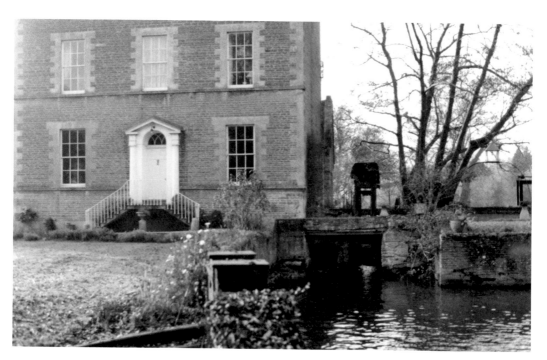

Lolham Mill house, 1989, dated to 1810. The last miller listed was Wm. Rickett 1928–9.

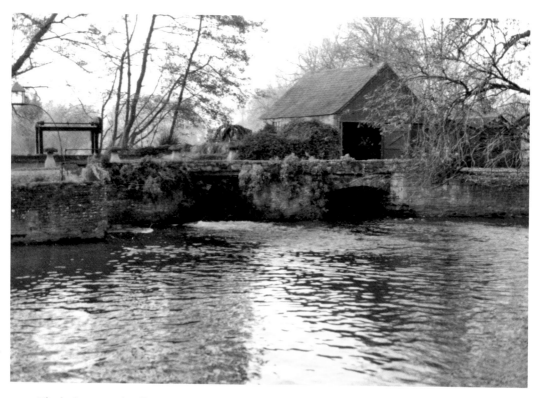

The lock gate and mill stream at Lolham Mill, 1989.

*Grid Ref 110082* Lolham Mill is named on the 1824 0.5 and stood on the West side of the Roman Road, which at this spot is known as King Street. It is not on the 1906 or 1963 1 inch. It was on the lower branch of the Welland.

Miller

1828–9   Wm Rickett        Corn Miller       West Deeping

## West Deeping
Situated south of the village just above Lolham Mill.

The following information was taken from the Archives of The Museum of Lincolnshire Life – Lincoln.

*Stamford Mercury 27 October 1795* To let on lease or otherwise and entered upon immediately a very good corn Watermill situated at West Deeping.

Apply to Messrs Joseph and Stephen Castledine of Manthorpe.

*Stamford Mercury 1828–29* John Thorne and Son Corn Millers West Deeping.

Kelly's Directory of 1900 gives Wm Fullard West Deeping and 1905 Fred C Fullard in addition to Wm Anstee for some years.

According to the Miller of 5th October 1896 Mr Fullard had just bought the West Deeping Mill.

*Stamford Mercury 4 November 1836* To be sold by private contract all that water corn mill in West Deeping in the County of Lincoln, situated on the River Welland. Apply to Mr Wm Thorpe the tenant.

*Stamford Mercury 23rd May 1856* Fire at the Water Mill occupied by Mr James Greaves, near the Church at West Deeping. Two mill workers were burnt to death one being Mr Edward Wright.

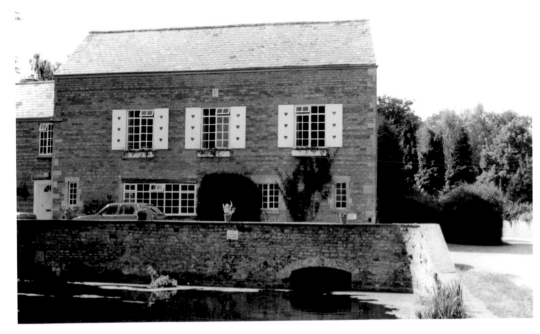

West Deeping Mill house and mill stream, 1985.

*The Miller Magazine 5th October 1896* The West Deeping Mill in Lincolnshire was put up for auction last month, and found a purchaser in Mr Fullard of Thomey.

Millers

| | | |
|---|---|---|
| 1826 | John Thorpse & Son | Corn Millers |
| 1835 | John Thorpe | Miller |
| 1842 | George Little | Miller West Deeping |
| 1842 | John Thorpe | Miller |
| 1872 | John Molecey Twigg | Miller |
| 1876 | Annie E'beth Gross | Miller |
| 1882 | John Molecey Twigg | Miller |
| 1896 | William Anstee | Miller and Tax Collector |
| 1898 | William Anstee | Miller and Tax Collector |
| 1899 | William Anstee | Miller and Tax Collector |
| 1900 | William Anstee | Miller and Tax Collector |
| 1904 | William Anstee | Miller and Tax Collector |
| 1905 | W. A. Anstee | Miller and Tax Collector |
| 1905 | W. A. Anstee | Miller and Tax Collector |
| 1906 | W. A. Anstee | Miller and Tax Collector |
| 1907 | W. A. Anstee | Miller and Tax Collector |
| 1909 | W. A. Anstee | Miller and Tax Collector |
| 1910 | W. A. Anstee | Miller |
| 1916 | W. A. Anstee | Miller |
| 1917 | W. A. Anstee | Miller |
| 1918 | W. A. Anstee | Miller |
| 1921 | NO MILLER MENTIONED | |
| 1923 | J. P. Teesdale | Miller |
| 1924 | J. P. Teesdale | Miller |
| 1926 | J. P. Teesdale | Miller |
| 1927 | J. P. Teesdale | Miller |
| 1929 | J. P. Teesdale | Miller |
| 1930 | Lake | Miller |
| | J. P. Teesdale | Miller/Farmer   Cromwell House |
| 1931 | NO MILLER MENTIONED | |
| | T. Crawford | Mill House |
| 1933 | NO MILLER MENTIONED | |
| 1934 | NO MILLER MENTIONED | |
| 1936 | NO MILLER MENTIONED | |
| 1938 | Wortleys | |
| Onward | Crawford | |
| | Clarke | |
| | Neil | |
| | Henry Tinsley | |

## Tallington Mill
Millers

| | | |
|---|---|---|
| 1856 | John Paine | Corn Miller |
| 1863 | John Paine | Miller |

| 1872 | John Paine | Miller |
| 1889 | Mrs John Paine | Miller – Water |
| 1901 | Mrs Bell | Miller |
| 1901 | Sanderson A. | The Mill |
| 1917 | Miss Berridge | The Mill House |
| 1922 | Miss Berridge | The Mill House |
| 1926 | Miss Berridge | The Mill House |
| 1933 | Mrs Vines | The Mill House |

The last four are listed now as private residences.

### Hudd's Mill

Hudd's Mill is situated off Priory Road Stamford, and is now two-storied and built of large squared masonry. It stands across the mill stream and dates from the first half of the seventeenth century, with stones carrying various names and eighteenth-century dates.

In 1770 the mill was leased to Thomas Boughton on condition that he spent £200 on building a house and repairing the mill. Various alterations have been carried out over the years.

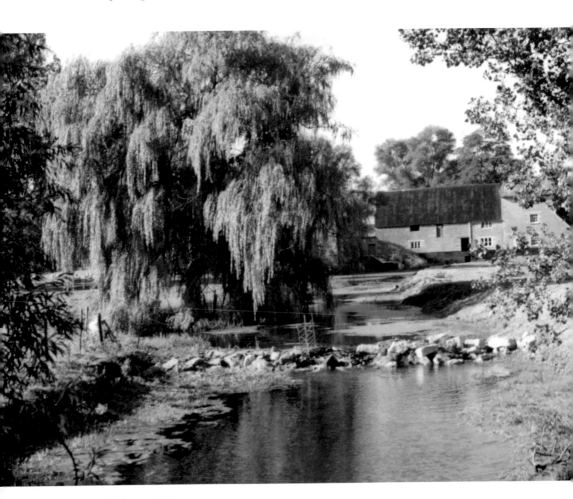

Approaching Tallington Mill, 1990.

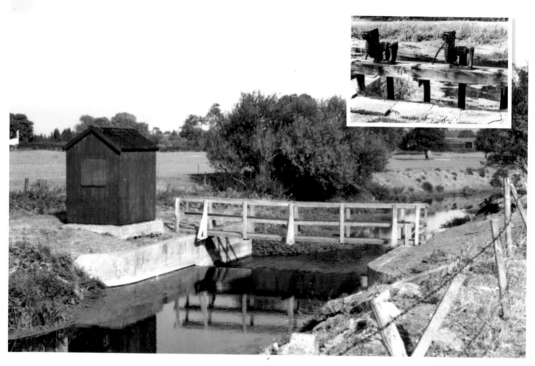

Automatic weir beyond Tallington Mill, 1990.
*Inset:* Remains of the sluice at West Deeping Mill, 1995.

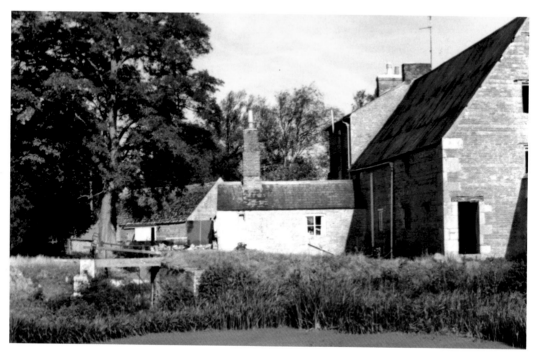

Rear view of Tallington Mill, 1990.

River Welland beyond Tallington Mill, 1990.

In the South Gable is an incised inscription which reads as follows: IRELAND 164...

The following information regarding Hudd's Mill was taken from the archives of The Museum of Lincolnshire Life – Lincoln.

*Sun Fire Insurance Policy No. 558181 20 June 1789* James Oldershaw of Stamford in the County of Lincoln. On utensils and stock in a Silk Manufactory stone built and slated situation in the Parish of St John in Stamford aforesaid £800.

On the mills including the machinery therein £200.

*Stamford Mercury 28 January 1814* On Saturday last Mr Job Topley an industrious man in the employ of Mr Smith, Miller of Stamford, was employed in clearing the insides of the water mill wheel at Hudd's Mill.

And in order to set the machinery in motion he accidentally slipped and was precipitated into the recess of one of the ladles unfortunately hit his neck and another caught him across the loins by which he was instantly killed in the presence of a young man who was assisting him to move the wheel and narrowly escaped the same fate.

*Stamford Mercury 3 September 1824* To be let.

The use and occupation of all that Water Corn Mill, called Hudd's Mill.

The property of Corpn Of Stamford, situated within a quarter of a mile of the town, upon the River Welland, having four pairs of stones, and at which for many years business has been carried on to a great extent.

Apply Town Clerk.

*Stamford Mercury 26 August 1825* At a common hall of the Corpn Of Stamford held yesterday, a lease of Hudd's Mill on the River Welland for 21 years was granted to Messrs Munton, Clifton and Co, at a rent of £80 per Annum.

To be sold a strong Oval steam engine Boiler, in good repair, 9 foot 6 inches long by 5 foot wide and 6 foot high. Also an 18 inch Four Cylinder 6 foot long, with brushes and cases complete, nearly new, and a Smut machine 12 inch diameter and 5 foot long, with hair and cane brushes and case complete. Apply to Mrs Clement Rubbins in Stamford.

*Stamford Mercury 15 February 1839* Wanted, an experienced miller to take the Management of a water mill.

Apply to Mr Palmer, Hudd's Mill, Stamford.

On 1776–8 map site is marked St Leonards.

*Stamford Mercury 12 September 1856* To be let and entered upon on the 29th of the present month. That portion of Hudd's Mills now and for many years past used as a flour mill. On River Welland, east of Stamford and named on 1835 St Leonards.

*Grid Reference 042075* Hudd's mill was just East of St Leonards Priory, on the River Welland, between the town and Newstead, and a little east of the present railway junction. It is marked on the 1906 OS 1 in. but not shown on the 1963.

Named Hudd's Mill on the original survey.

Millers
| 1828–9 | Clifton   Corn Miller | Stamford and at Bourne |
| 1849 | Isaac Rubbins | Hudds Mill |
| 1855 | Isaac Rubbins | Hudds Mill |
| 1861 | Isaac Rubbins | Priory Mill |

Approaching Hudd's Mill, 1990.

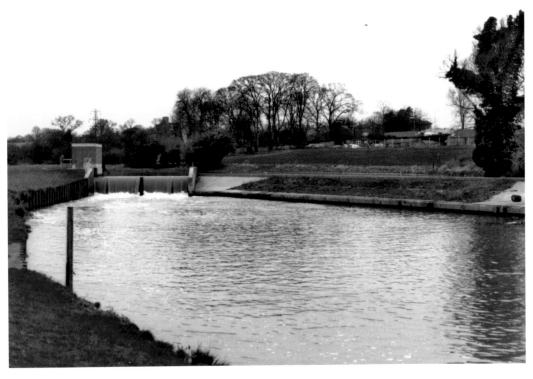

Approaching Hudd's Mill, weir and pumphouse, 1990s.

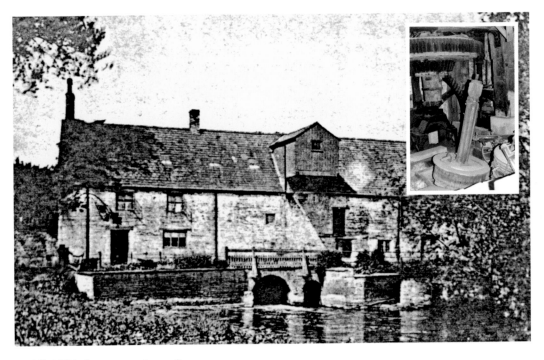

Hudd's Mill before restoration, 1989.
*Inset:* Hudd's Mill under the course of restoration, *c.* 1989.

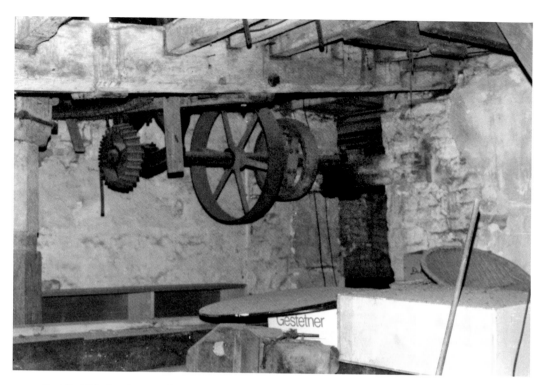

Hudd's Mill showing grinding gear, 1989.

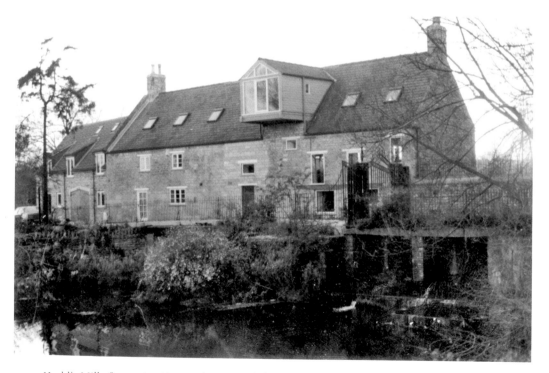

Hudd's Mill after restoration work was carried out, 1990s.

## King's Mill

A mill has been on this site since Domesday, being situated in Bath Row Stamford. It was formerly known as North Mill, and is so called in a list of King John's possessions.

In 1629 a conveyance of land refers to a new millstream being dug for King's Mill or North Mills. The new dyke was completed c. 1640 when the present mill was constructed.

The seventeenth-century building has two stories, with coursed rubble walls, ashlar plinth and an L-shaped plan.

In around 1793 a long granary was added on the north side; it was built by Joseph Robinson, the tenant miller, under a building lease of January 1793 in which he was obliged to spend £400 within two years on the work. It also is two storied, with a slated mansard roof, and coursed rubble walls.

There is a further section of early nineteenth-century building. This includes two two-storied granaries on the East and the South.

The following information regarding King's Mill was obtained from the Museum of Lincolnshire Life – Lincoln.

> *Stamford Mercury 27 October 1786* Wanted – a miller – apply to Mr Robinson King's Mill Stamford.
>
> *Royal Exchange Fire Insurance Policy No. 178571 1 November 1800* Joseph Robinson in the Parish of Stamford and County of Lincoln, miller. On his Water Corn Millhouse, Granaries and Offices all adjoining situate in All Saints in the aforesaid, stone built and slated £800. On standing and going gears, millstones and machines therein £200. Warranted no steam engine.
>
> *London Gazette 18 March 1815* Horatio Gilchrist, Stamford, Lincs, Miller named in a list of creditors of John Bradshaw late of Leicester, Baker. A prisoner of debt in the Fleet prison.
>
> *London Gazette 29 April 1815* Valentine Jelly of Stamford, Rutland, Lincs, Miller, named in a list of creditors of John Batty formerly, and late of Melton Mowbray, Miller, now a prisoner for debt in the gaol of Leicester.
>
> *Stamford Mercury 23 November 1810* During a storm on Saturday night the King's Mill at Cliffe and in the occupation of Mr Gamble was blown down.
>
> *Stamford Mercury 29 August 1828* To be sold by Auction. A well built Water Corn Mill and Bone Mill lately erected upon the newest construction with a dwelling house situated on the River Welland nearly adjoining the town of Stamford. Held on lease from the Mayor, and Aldermen and Capital Burgesses of Stamford for 21 years 18 of which are expired, and on 29th day of September next.
> Apply to Mr Ullett of the Mills.
>
> *Stamford Mercury 13 March 1846* To be let for a term of 21 years – an excellent Water Corn Mill situated on the River Welland in the Borough of Stamford by order of the Town Council of Stamford.

Two wheels and their gearing still survive. The great spur wheels are built on top of the bottom flanges, of either trundle or lantern gears, which still have the holes for the staves. The mill was built in 1699 and enlarged about 100 years later, by building out on three sides leaving the mullioned windows in place inside and the old doorways too.

King's Mill was so named in 1885.

Millers

| 1826 | Horatio Gilchrist | Waterside |
| 1828–29 | Horatio Gilchrist | Waterside |

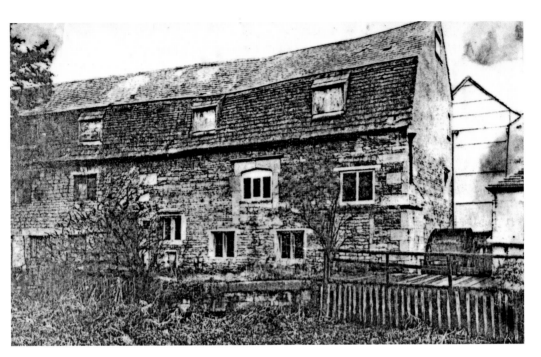

King's Mill, Stamford, the last water mill between Market Deeping and Stamford, 1950s.

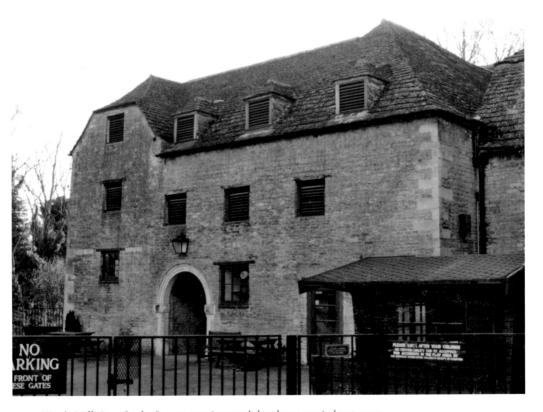

King's Mill, Stamford, after restoration work has been carried out, 1990.

| 1835 | Horatio Gilchrist | King's Mill |
|------|------------------|-------------|
| 1842 | Thomas Gilchrist | King's Mill |
| 1849 | Thomas Gilchrist | King's Mill |
| 1855 | Thomas Gilchrist | King's Mill |
| 1861 | Mrs S. E. Gilchrist | King's Mill |
| 1868 | Thomas Jelley | King's Mill |
| 1872 | Thomas Jelley | King's Mill |
| 1889 | Thomas Jelley | King's Mill |
| 1892 | Thomas Jelley | King's Mill |
| 1905 | Molesworth and Springthorpe | |

Much of the original machinery is still intact and the present owner Mr Chamberlain is in the course of renovating the mill and I am indebted to him for allowing us to take numerous photographs.

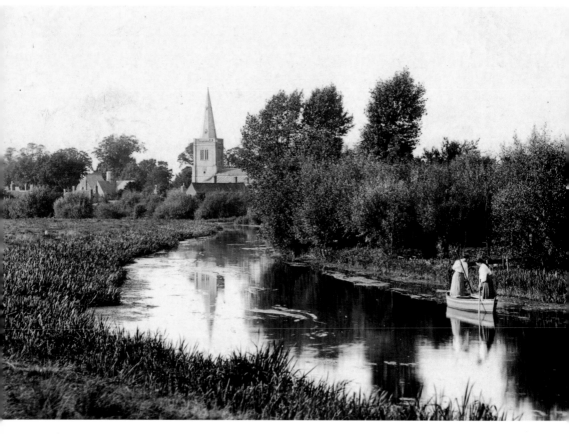

Adjacent to Eastgate one of the large poplar trees was blown down during the horrendous gale of 1947. This picture is from *c.* 1905.

# 3

# Sport on the Welland

*Fishing – Skating – Boating – Water Sports*

In earlier times the river had always played an important part in the livelihood of village folk, whose settlements, cottages and mills were built along its banks.

## Fishing

However, at the beginning of this century eel catching and fishing in general were carried out, but rather for supplementing the income than purely for sport. Older residents will remember seeing Mr Harry Buck using his 'spirit' pole – this was a long pole tipped with a kind of steel prong, no one seemed to use oars in those days – to propel his punt in an almost dead straight course down the river to lay his wicker eel 'lepps' or traps; these would be made secure on the river bed by using a stout willow stick. The next morning he would again take his punt down the river to collect his catch, then, if it had been good he would eventually make his way round the village with a hand cart and sell the freshly caught eels.

Mr W. Robinson Snr was a well-known resident in Bridge Street, Deeping St James at the turn of the century. He was the local Water Baliff as well as an expert fisherman, and together with his wife they used to take his catch of eels, taken from the Welland, in specially prepared boxes to Stamford where they would be dressed and sold to waiting customers.

Their son John carried on as Water Bailiff and he would often be seen walking along the river banks collecting fees from local and visiting fishermen; he too was also a keen angler.

Another local angler was Mr Fred Popple of Eastgate, he was a slightly built man, but nevertheless he would very skilfully punt his boat up and stream until he came to a favourable spot, then with his varying rods and keep nets he would settle down for either a morning or afternoon fishing session. Over the years he had taken a number of good specimen of pike from the Welland and these looked very realistic and rather frightening to any youngster who may have been invited to see them mounted in their glass cases at his home.

Mr Sherrard and his son Bertie, also residents of Eastgate, were keen anglers at the turn of the century.

In the photographs shown following notice the very different clothing which was worn for the sport around 1911.

The Deeping Angling Club, between 1969 and 1971, went to considerable trouble to acquire the nine individual shares of the owners of the fishing rights, so as to avoid any possibility of the fishing rights being offered on the open market, with its consequent high risk of a sale to an outside organisation, which could have resulted in the local inhabitants being precluded from fishing.

The fishing rights of the club extend from between Molecey's mill and Thorpe's mill on the Stamford Road to Waldram Hall and on to Kenulph's Stone, in the Parish of Deeping St James on the Deeping High Bank; a distance of some 6 miles.

The Deeping Angling Club is a very thriving and popular club. Nowadays, of course, fishing is purely for sport and it is nice to see the fishermen lining the banks of the river for their Sunday

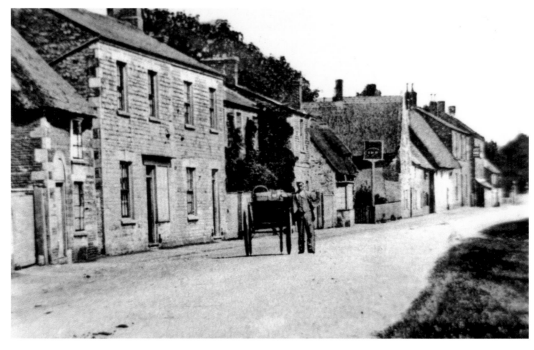

Mr Harry Buck on his way delivering eels which he had caught in the river, along with a few rabbits he had shot.

# MARKET DEEPING ANGLING SOCIETY.

The Proprietors of the Right of Fishery in the River Welland, from Market Deeping Bridge to Kenulph's Stone, in the Parish of Deeping St. James, HEREBY GIVE NOTICE that all persons found taking fish, by any means, in the above-named portion of the said River, without leave, will be prosecuted.

N.B. Annual Tickets for Angling only will be granted upon payment of 5s., on application to the Secretary of the Society, and subject to the Rules thereof

BY ORDER,

SAML. B. SHARPE,
*Hon. Sec.*

Market Deeping,
May 30th, 1881.

J. S. Clifton, Printer, Market Deeping.

Market Deeping Angling Society notice.

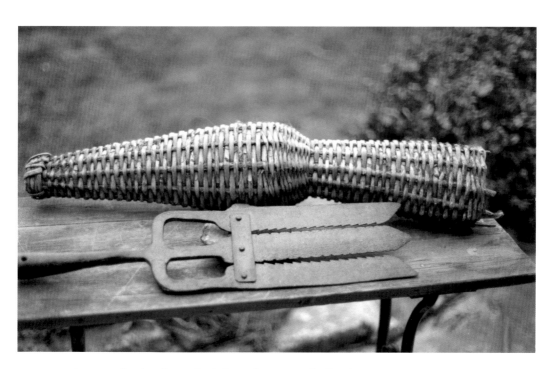

An eel trap made of wicker and eel glave; this was made illegal many years ago.

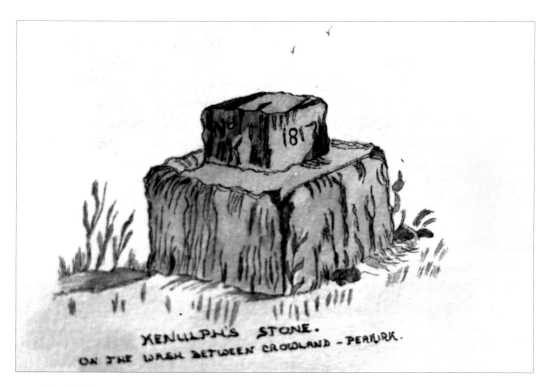

KENULPH'S STONE.
ON THE WASH BETWEEN CROWLAND - PEAKIRK.

Kenulph's stone.

Mr W. Robinson and sons selling freshly caught eels at Stamford, *c.* 1915.

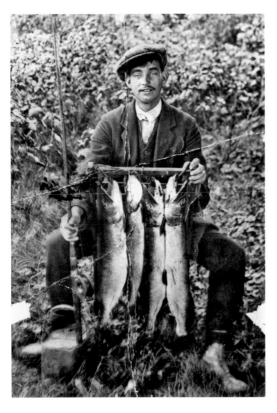

Mr John Robinson with a catch taken from
the Welland.

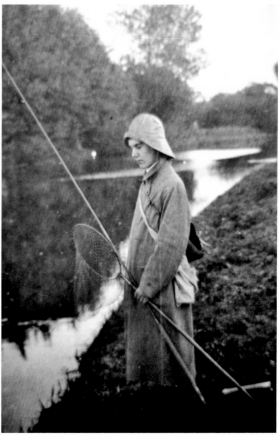

Mr Sherrad (above) and his son Bertie
(below) fishing in the Welland. Bertie
was killed during the First World War
while serving as a young army officer.
There is a memorial brass plaque in his
honour in Deeping St James Church.
Photographs were taken in 1911.

morning matches. The catch is kept in a large keep net in the river until the match is over and after the 'weigh-in' the fish are returned to the water. There are many species of fish in the Welland, and to name but a few there are eel, pike, tench, chubb, roach and perch.

I came across the following 'Welland Tragedy' a short time ago, which is a sad tale:

A Singing Fisherman's Farewell

1
Dick the Angler sat
On the Welland Bank,
And sang with the voice
Of a fishing crank
He kept the same place
For a mortal while,
He baited his hooks
In a Waltonian style,
But never a fish
Would e'er approach him,
Whatever on earth
Is the reason Jim.

2
I've baited my hooks
As they should be done,
With a fine fresh dab
And a H'penny bun,
I've thrown out my line
And I've sat quite still,
While the days were hot
And the nights were chill,
But never a fish
Has nigh come to me,
From out of the depths
Of the sad salt sea.

3
O, the days were hot
And the nights were cold,
And this Spalding man
Was a sailor bold,
He muttered I think
It's a trifle rough,
For a beautiful place
And such humble stuff,
That float where they will
So perfectly free,
Should just flick their fins
To make a game of me.

4
Yes, beautiful plaice
And a host of fish,
That look at their best
On a nice big dish,
Did ought to take hold
Of my odds and ends,
I dangles above
Them all day, my friends,
The float it may bob
And the hook it may glint,
But never a one
Of them takes the hint.

5
Dick dangled above
Them such tempting things
And also to please,
Them he sits and sings
A song of the waves,
That are wild and wet,
An ancient old tune
That he can't forget,
But nothing comes out
Of the froth and foam,
He might as well be
With his pipe at home.

6
That ancient old song
Is a sort of spell,
That creatures with fins
Understand quite well,
And knowing its like
To the call of fate,
All in a minute
They swallows the bait,
But something's gone wrong
(And it's mortal queer)
For none of the fish,
That are there come here.

7
All in a minute
He uttered a shout,
The float disappeared
And the line ran out,
And Dick followed on
(Being old and slow)
Though whether the thing
That was tugged him so,
Was sick of his song
Or desired a snack,
We never shall hear
Unless he comes back.

8
But whether the thing
Was a hungry whale

Or a monstrous shark
With a monstrous tail,
Or some sort of beast
Like an Octopus,
That may concern him
But won't affect us,
He's vanished for good
Has this poor old lad,
And really some think
(On the whole) you're glad,
If reinstated
And free from the mess
You'll see it stated
In the next 'FREE PRESS'

By: E. A. J.

## Skating

Over the years there have been various sporting activities on the Welland in the Deepings, and especially in very severe winters when local residents – young and old alike – would always hope for a spell of skating and anxiously watch for the first thin covering of 'cat-ice' to develop into a thickness which would eventually prove safe enough for skating, and then many happy hours would be spent on the ice.

As a young man, my father, along with other local people, used to skate down from the Deepings to Crowland and the Washes. Here there would be plenty of activity in the way of competitions and races to take part in, and the lucky winners were often rewarded with joints of meat, loaves of bread and sometimes potatoes as their prize. These were very welcome prizes too, as most men were employed in agriculture in those days and in severe weather it would be almost impossible to do this kind of work, quite often for several weeks at a time.

The twelve mile stretch of Cowbit Wash was a very popular venue not only for local skaters; people would come from all over the country, for it was recognised as being the best skating course in England, and the railway companies would run excursions every day from London and the large towns when all manner of horse drawn vehicles were seen waiting at the station to take the skaters to the Wash.

A spectacular sight on the Wash would be the food stalls, coconut shies, and braziers with roast potatoes and chestnuts. Hundreds of chairs would be taken down to the ice by men who had been made unemployed by the severe weather; here a few coppers could be earned by putting on people's skates and helping to take them off again.

I was allowed to go skating on the Welland for the first time at about the age of 10 (previously it had always had to be on the Leather Pits in Deeping Gate where the water was relatively quite shallow) being under the watchful eye of builder Mr Billy Crowson.

The skates which I used at this time were the Fen Runners, seen in the photograph below. At first they were loaned to me by Mr J Boyden and eventually were bought for me at the then quite expensive sum of 2/6d; I eventually graduated to Canadian figure skates.

A brief description and photographs of skates of those days follows.

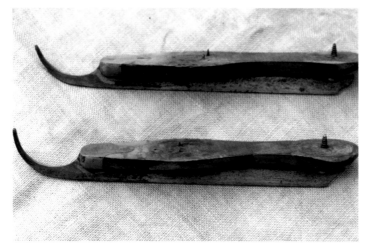

'Fen Runners'. This type were screwed into the heel of the boot and held in place with a leather strap which went round the ankle. A longer strap went around the foot twice. The base of the skate was made of wood with three pairs of slots cut into it to take the straps. Made by: J. Sorry, Sheffield. The name J. Boyden (our local carpenter in the 1930s) is engraved on the brass toe plate.

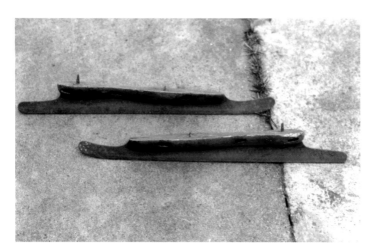

Early racing skates. These were made between the years 1800 and 1805 only, in order to compete with the Dutch speed skaters of the time, the base of the skate being very similar to the Fen Runner with a speed skate blade similar to the Dutch type. Made by: James Howeth, Sheffield.

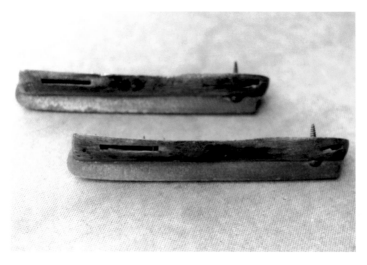

Ladies' Figure Skates: Ladies Canadian Figure Skate (Pathfinder). These were easily fixed by metal plates and a series of screws into the sole heel of the boots. Made by: C. C. M. Canada.

Ladies' Canadian figure skates.

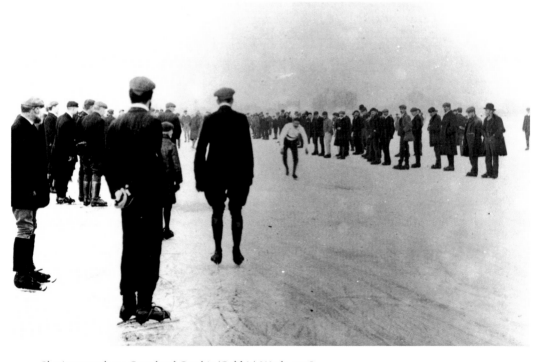

Skating match on Crowland-Cowbit (Cubbit) Wash, 1908.

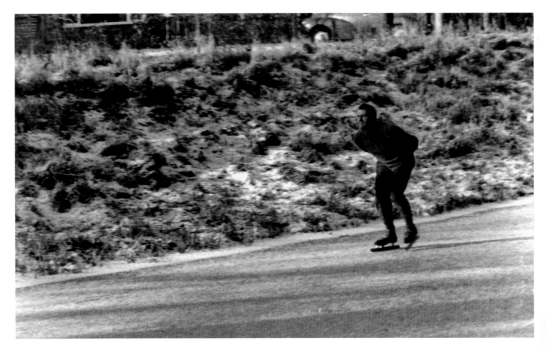

A skater on the Welland adjacent to Church Street, Deeping St James, on 1 December 1973. Norwegian Speed Skates being used.

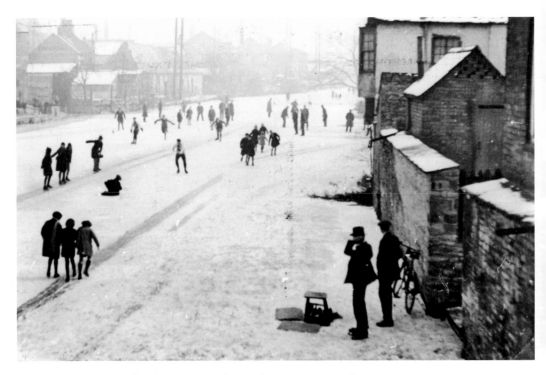

Skaters on the River Welland at Stamford during the severe winter of 1947.

## Boating

Boating has always been a very leisurely pastime, but not everyone who had gardens backing onto the river owned a boat, especially before the Second World War. However, these could be hired out from one or two local owners and the charge for this would be around 3*d* or 6*d* an hour.

Mr Fred Popple was one owner. He had three boats and often holidaymakers would hire them out and he usually charged 3*d* per hour.

I have also been told that during Deeping Feast week his boats would be gaily decorated with bunting and flowers by members of his family who always came home to Deeping specially for the Feast. But the boats would not actually be taken out onto the river until the evening, when lanterns would be used to light the way if there wasn't a full moon.

At Market Deeping boats could be hired out from the 'New Inn', now the 'Deeping Stage'. Nowadays, most people living by the riverside own their own boats so hiring is a thing of the past. However, a new registration fee did come into force during the summer of 1990, whereby owners of rowing boats are charged an annual fee of £2; upon payment of this a small disc is issued which has to be displayed on the boat.

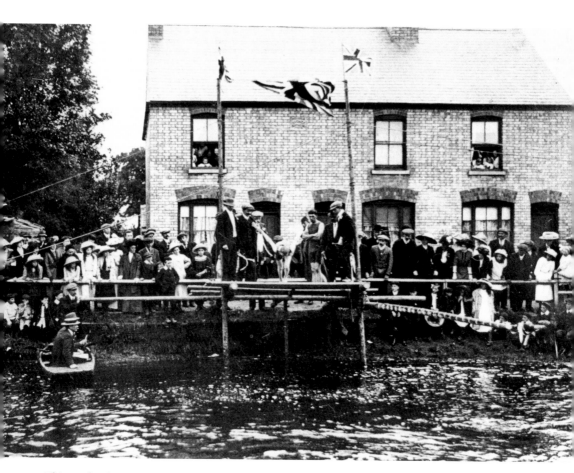

This used to be a very popular event. Mr Edmund Waterton seen on the left standing on the platform, 1914.

*Left:* Mr Fred Popple, our neighbour around 1930s. He had a 'fleet' of rowing boats, which he hired out at sixpence an hour, but always using a sprit pole, not ours. Adjacent to Eastgate, 1930s.

*Below:* A group setting from the New Inn, not the Stage, *c.* 1910.

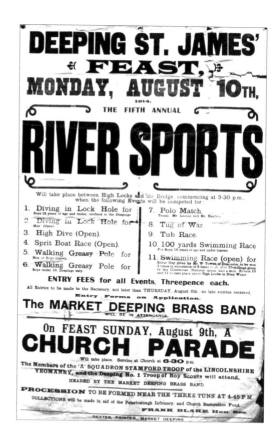

*Right:* River sports poster, 1914.

*Below:* Between High Locks and the bridge, Deeping St James, 1914.

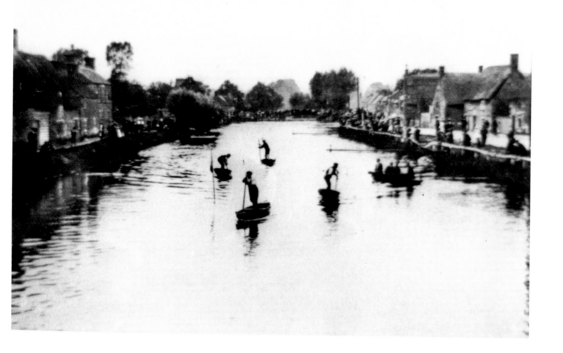

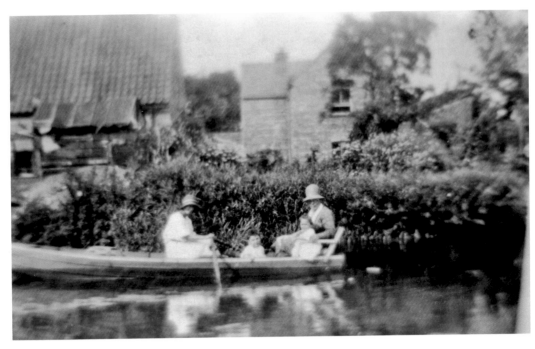

A leisurely afternoon at Market Deeping, 1912.

## Water Sports

At the turn of the century, the very popular Water Sports was held on the stretch of river between the High Locks and the bridge during Deeping Feast week. The sports were usually organised by Mr Waterton of Deeping Waterton Hall.

There were various events to be competed for and I list a few as under:

1  Diving in the Lock Hole   Boys 16yrs and under (Deeping only)
2  Diving in the Lock Hole   For men
3  High Dive                 (Open)
4  Sprit Boat Race           (Open)
5  Walking greasy pole       Men or boys only – open
6  Walking greasy pole.      Boys under 16yrs. (Deeping only)
7  Polo match
8  Tug of War
9  Tub race
10  100 yds swimming race    Boys under 16yrs. (Deeping only)
11  Swimming race (open) for Silver cup – given by Mr Towns of Doncaster, to be won 3 times in succession or 5 times in all, also 10 shillings given by the committee.
Distance about half a mile.
Events 10 and 11 to take place above High Locks in deep water.

There was very little in the way of sporting activities on the river after the Water Sports ceased to be held. But in 1953 several water events were organised to celebrate the Queen's Coronation. The photograph opposite shows an event taking place opposite the library.

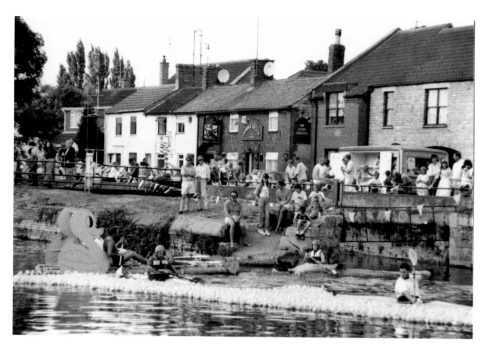

The Duck Derby at the High Locks, 1991. This event is held every year in support of local charities.

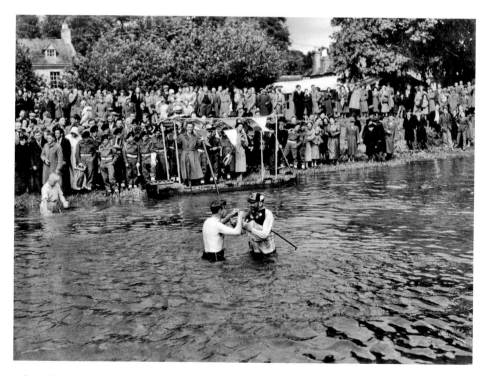

Taken during the celebrations for our present Queen Elizabeth II, 1953. Opposite 'the Parks', now the library.

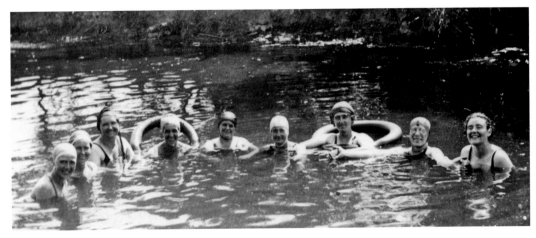

Left to right, *c.* 1920: Mrs Peg Soames, Min Crowson, Mrs Petch, Hilda Crowson, Mrs Woods, Mrs Pop Bennett, Mrs Pat Feneley, Miss Marshall, Mrs Lol Mulligan.

In more recent years the annual Raft race is held to benefit local charities. The home-made rafts are ingeniously made, consisting of old oil drums or plastic drums with planks of wood across to hold them together.

Another popular event is the Duck Derby; this is usually held in September, when well over 3,000 small yellow plastic ducks are released into the water at the High Locks and allowed to float down river to the bridge, a distance of around 300 metres. This sponsored event is organised by the Deepings Lions and again is to benefit various charities.

The river is often used by the local Scout group in the summer months to practise the art of canoeing. Their Headquarters are at the former Infants School in Church Street, Deeping St James.

I have frequently been asked about the 'Dippings': where were they, and what were they for, so as a small postscript I will make a brief mention here. Initially they were a means of access to the river from the street, and were sloping pieces of ground which went down to the waters edge, and were often put to various uses.

I will list them as I remember them, but there may have been more.

So starting from lower Eastgate, the first one was just below the Low Locks, and as Eastgate had quite a few dairymen, the cows would often be taken down to the water for a drink. It was always hoped, of course, that the cows would not stray through the shallow water and end up at the Locks.

The next one was just before the Cross, and I well remember this being used for fire practise, when the fire engine would be wheeled down from its 'house' on Church Street, next to the Institute, by six men, and with a lot of human effort water was taken from the river with, eventually, a jet of water coming from the hose but never quite making it to the opposite riverbank. This 'Dipping' has now been built on.

The third was in Church Street, between the two grass areas, and a fourth was almost opposite the butcher's, Gaskin and Buff.

I believe there were several others on the roadside into Market Deeping. The children always had their own favourite 'Dipping' as not only were they ideal places for paddling, with the water no more than ankle deep at the edges, but they were equally popular for fishing with a net, always hoping to catch a few 'tiddlers'.

After the 1947 flood the river banks were raised and the 'Dippings' filled in.

# 4

# Floods

Over the years the Deepings have seen their fair share of floods, and in 1877 the *Stamford Mercury* reported the following passage:

> The Welland has again overflowed its low banks and inundated the streets, footways, and the lower rooms of many of the houses. This is about the 15th time such serious inconvenience has been experienced in 17 months. It is hoped the present year will see the river's bed which is in some places almost sanded up, lowered and cleansed, and the banks replaced. If the Welland Commissioners exist, with their Parliamentary powers and responsibilities, how is it that they permit the recurrence of these interruptions of traffic, loss to trade, and injury to health and property.

The next severe flood was in 1880 and I quote the passage as recorded in the *Peterborough Advertise* of 16 October 1880:

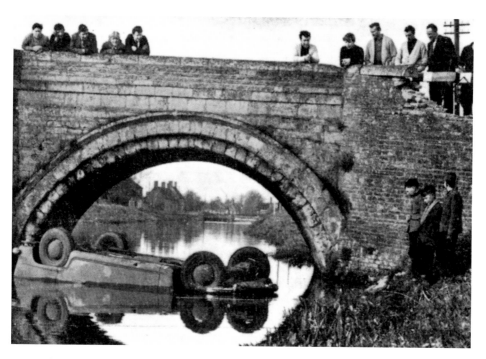

An accident on the bridge in 1968, a car crashed over the side of the bridge and overturned into the river. No one was hurt.

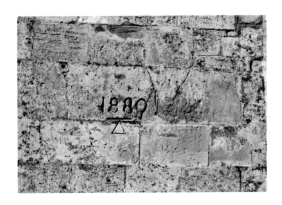

# FLOODS.

In 1570, the north end of the Stamford Town Bridge was borne down by a Flood, and re-built by William, Lord Burghley. In April, 1641, the Welland flowed half way up to St. Mary's Church, and was 16 inches higher than the Flood on Thursday, July 15, 1880.

John H. Howard, Printer, Stamford.

*Above:* Flood carving on Deeping St James Bridge, 1880.

*Middle:* An interesting announcement.

*Below:* St Swithin's Day, Stamford Town Bridge, taken during the Great Flood of 1880.

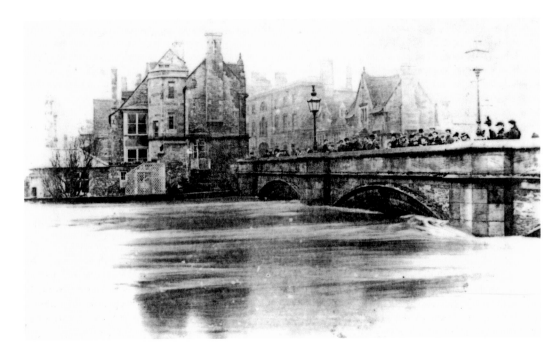

The whole central Counties of England including Northamptonshire, Warwickshire, Leicestershire, Lincolnshire have suffered heavily by the recent storms and floods, which have since extended to some of the Southern and Eastern Counties, London and adjacent counties. The roads at Deeping St James soon became impassable on foot, and Horsegate Road was navigable. The new High Road made as a precaution in Deeping St James also became impassable and the houses inundated to a depth of several feet.

Years ago I remember my Grandmother telling me that during this flood she was living in Horsegate and she saw baby pigs floating down the road on hummocks of straw. So obviously they had been swept from their sties by the rushing water.

On the Deeping St James bridge there is the date of 1880 carved into the side of one of the arches, which records the level of the flood at that time.

The next disastrous flood was in August 1912. This was known as the 'Harvest Flood' and caused havoc with the corn harvest. In cases where the corn was still standing in the stooks, some of the crop was washed down, which made it totally useless, but some farmers were rather more fortunate as where they could, they employed gangs of local men and women to move the stooks to higher ground.

Another serious flood was in January 1939 and several photographs follow showing the height of the water at well-known places in the village.

The last severe flood in the Deepings was in March 1947 and will be remembered by many local residents. I particularly remember 20 March, as on that day a friend and I travelled into our office in Peterborough where we worked together, thinking it would be just another routine day. As our bus took us along the Peterborough Road, we did notice there was rather more water than usual in the small stream alongside the Nine bridges.

In those days the Etton Road was a favourite camping place for the gypsy families, and on this particular morning everything looked as normal, with their gaily painted caravans making a colourful picture, and their horses were tethered by the roadside. There were lines full of brightly coloured washing blowing in the wind.

However, during the morning we had telephone messages to get home as quickly as possible as the flood water was rising rapidly. This we did, and on reaching the Nine bridges it was almost an unbelievable sight to see the water rushing over the tops of the hedges, and adjoining fields already under several feet of water. There was no sight of the gypsy families, caravans or their horses, only their washing, which had been caught up in the briers, so obviously they had had to make a very hurried departure.

When we arrived in Deeping St James, Church Street was flooded and later on during that day the water rose to such an extent that it swept around the Cross corner into Broadgate Lane like a tidal wave.

Unfortunately, I have very few photographs showing this flood in the Deepings as it was just after the War and film was almost unobtainable.

At Market Deeping things were just as serious, with many houses on the riverside being flooded to quite a depth, and even as far as Towngate the streets were well underwater.

This flood was caused by weeks of severe frosts and snow, starting in January, on into February and well into March. The rivers were frozen almost solid in some parts, and when the thaw started in March the ice flowed in thick masses, making it almost impossible for the flood waters to get away. In some places, men stood on the bridges with long poles to guide the thick ice underneath.

On 21 March, the river burst its banks at Crowland, thus taking the water away from the Deepings but causing great havoc there. The breach in the Crowland bank measured some 60 yards and this caused serious flooding right across to the Stowgate smallholdings. Sandbagging alone was insufficient to contain the water, and eventually, with the help of the Army, 16 Buffalo

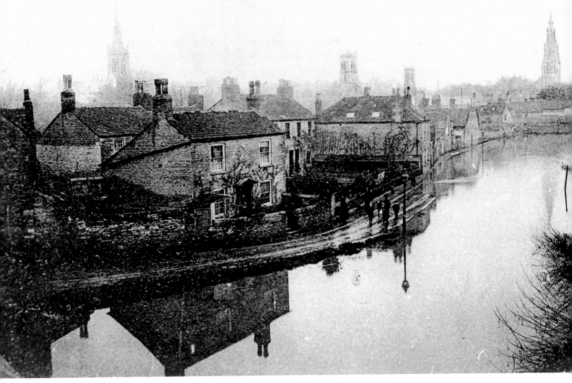

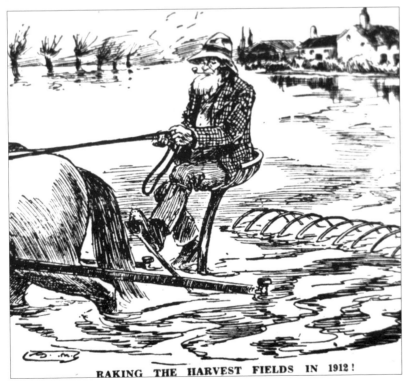

RAKING THE HARVEST FIELDS IN 1912!

*Above:* Perhaps this will be better than the Town Bridge! St Swithin's Day, 1880, Bath Row.

*Left:* As the caption says, 'raking in the harvest'.

Mrs Knowles, our
neighbour, taken
from her garden in
Eastgate, 1929.

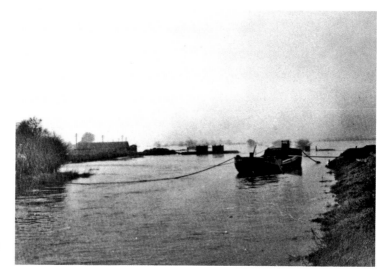

A flooded Welland near
Locks Mill, Spalding.

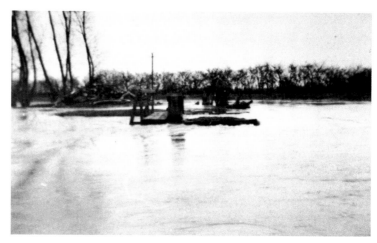

A flooded Low Locks,
Deeping St James,
January 1939.

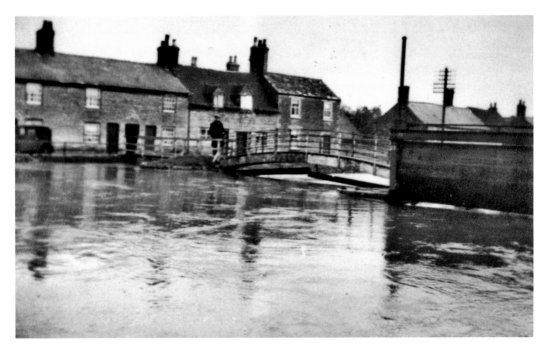

High Locks, Deeping St James, January 1939.

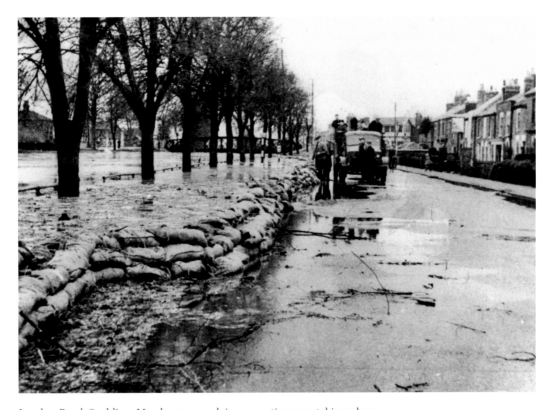

London Road, Spalding, March 1947; cradging operations are taking place.

amphibious tanks were used to fill the gap. This was the first time the danger bell in the Abbey had been rung since the great flood of 1880.

After this flood the Maxey Cut was built and also Hives Bank; this is the bank which runs through the gardens of the riverside houses in Eastgate. It was built by Italian and German Prisoners of War, and some of the spoil for it was taken from the Leather Pits on the Cuckoo Road and the adjoining field.

The work-box in the photograph shown on p. 74 was made for me by a German prisoner of war who was helping to build the bank in our garden. Apparently he had been a cabinet maker in Germany prior to the War.

The following interesting extract was taken from the *Stamford Mercury*.

**Autobiography**

To the Editor of the *Mercury*.

Sir,

Poor old Crowson, of Market Deeping, an eccentric character, who died on the 3rd of June last, in his 87th year, penned the enclosed piece of Biography a few days before his death, respecting which he gave especial injunction to his Executors, possibly you may feel disposed to favour the last wish expressed at the foot of it.

I am, yours &c., M.

7th July 1849.

John Crowson, born at Maxey, October 19th 1762. He lived at the Bertie Arms, Market Deeping nearly 20 years, and in all that time not a game at ninepins or other unlawful game was allowed; in the same house there was only one birth in the course of 100 years, and that was Thomas Butler, late Postmaster. Crowson was bailiff of the Manor of East and West Deeping for 40 years, under Messrs Pierrepont, Cheales, Forbes and Moore, the stewards.

He was the only Publican ever known in Deeping who gave up business to live independent, which he did till his death, though he kept the sign of the Battering Ram at Deeping St James, for nearly 30 years, and there it is to be seen now.

He remembered Deeping Bank breaking at Martinmas in 1770 which drowned Deeping Fen 7 feet deep in many places, but 6 feet on the average, seven miles from Deeping Bank to Baston Bank, and 9 miles between Deeping and Spalding, 63 square miles at 6 feet deep.

The greatest sufferer was W. Bailey, called Wikeham Bailey, who had 130 acres of cropping all lost, besides a pound an acre Drainage Tax. His own land ruined him entirely, and many others. It then set in such a severe and long frost as had not been known for years, and it went or broke up with such a strong W. wind that it destroyed the greater part of the houses, barns and mill all over the fen. By great industry and expense they got it drained and began to thrive, but in two years and a half at May fair, 1773 it rained for two days and nights, so it drowned it again by the downfall only. It was called the May flood. These were sad times for the poor fen farmers, arid now you farmers look at it and smile. All this poor old Crowson remembered well. He remembered several farms in the fen being sold for less than £5 an acre, but M J Mawby bought his under £3 an acre.

And this I should like to be put in the *Stamford Mercury*

Farewell.

*Left:* High Street, Market Deeping, 1929.

*Below right:* The Great Flood at Cross Corner, March 1947.

*Below left:* 1947: A workbox made for me by a German POW who was engaged with other workmen in building Hives bank in our garden. My mother used to supply 'the boys' with tea.

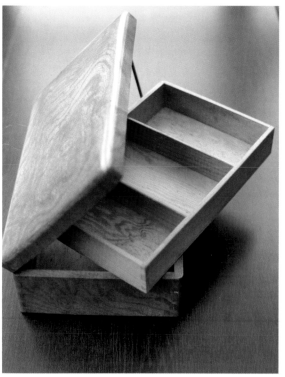

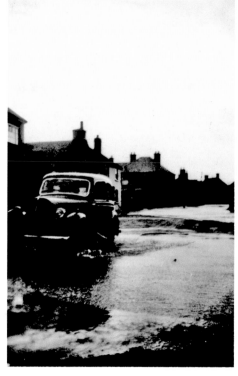

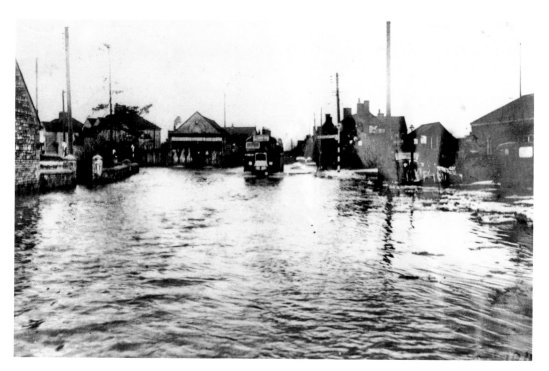

Co-op, Horsegate Junction, Deeping St James, 1947.

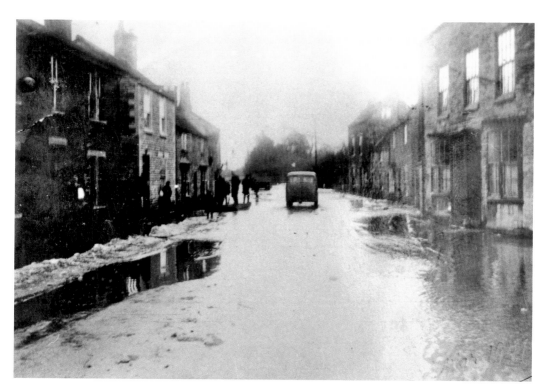

A flooded High Street at Market Deeping, March 1947.

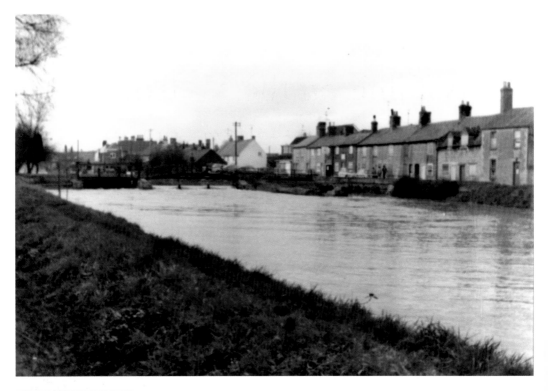

*Above:* The river in flood after the long summer drought, taken at the High Locks, Deeping St James, 1976.

*Left:* Torrential rain on 15 August 1980. 3 inches in twelve hours in the upper reaches of the Welland in Leicestershire, causing dramatic flooding in the Deepings.

# 5

# Wildlife on the Welland

*Swans – Mallard – Moorhen – Muscovy*

The riverbank offers all kinds of wildlife, but our 'resident' swans and their young are always firm favourites. All of the following photographs were taken on the river between the Cross and the Low Locks.

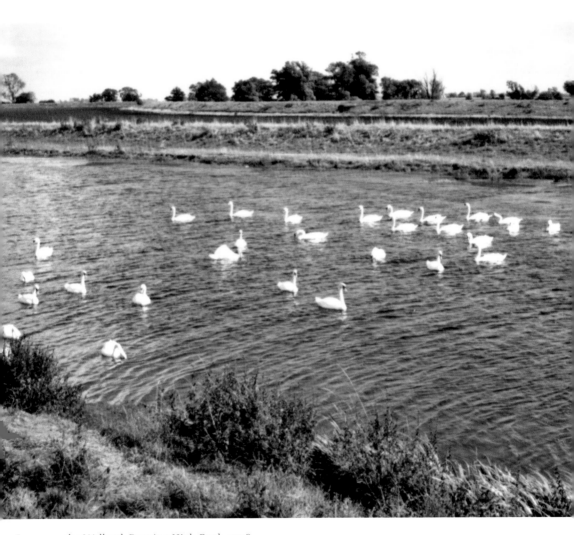

Swans on the Welland, Deeping High Bank, 1978.

Sheep grazing on Deeping high Bank, Welland in the foreground, 1990.

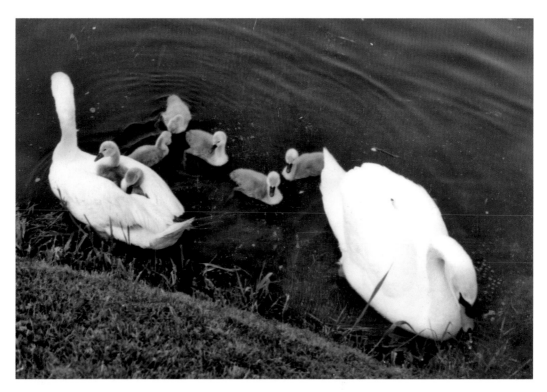

Our 'resident' swans (pet names Gregory and Belinda). Since this photograph was taken Belinda died by flying into electricity lines and Gregory has taken a new 'wife'.

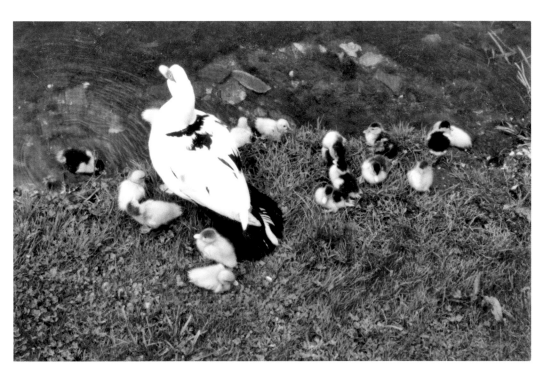

Muscovy and her newly hatched brood of sixteen ducklings.

Mallard nest and eggs.

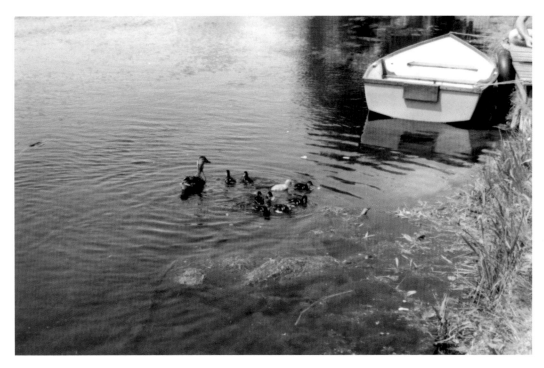

These photographs were taken in our neighbour's garden where the ducks had their nest.

This moorhen was building her nest in vain; no sooner had she laid her eggs then along came workmen on their weed-cutting operation and her nest and eggs were set adrift.

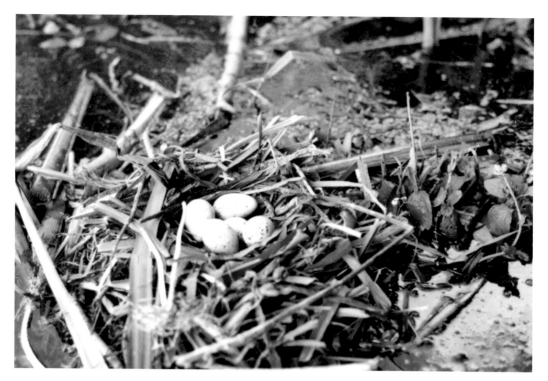

Moorhen's nest and eggs.

Cattle grazing on the riverbank opposite our garden, 1990.

Near the meadows, Stamford, 1990.

# 6
# Dredging Maintenance

*Dredging – Reed clearing – Clearing Weed*

Over the years the river has always been well maintained in the form of dredging, reed cutting from the side of the river bank and clearing weeds from the river bed. The following photographs were taken from just below the Cross to Bridge Street.

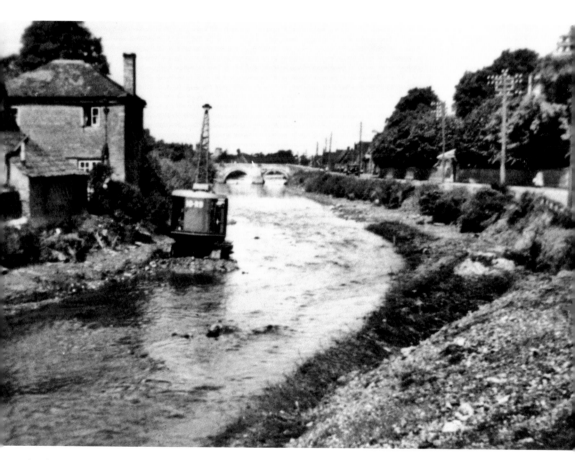

A dragline preparing for brushwood to be placed along the river bank, 1939–40.

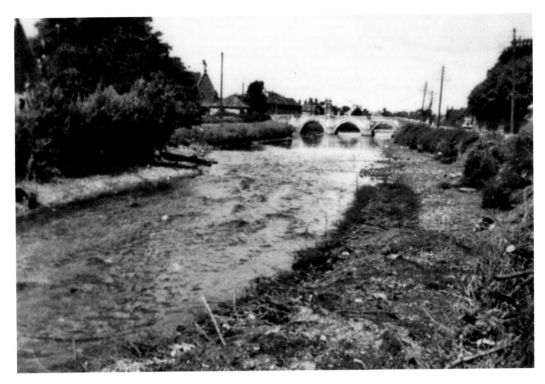

Note brushwood faggots in place by the bank side.

River bank after strengthening work has been completed, 1939–40.

*Left:* Mustang dragline clearing reed from the bank edge.

*Below:* 1969–70, after reeds have been cleared.

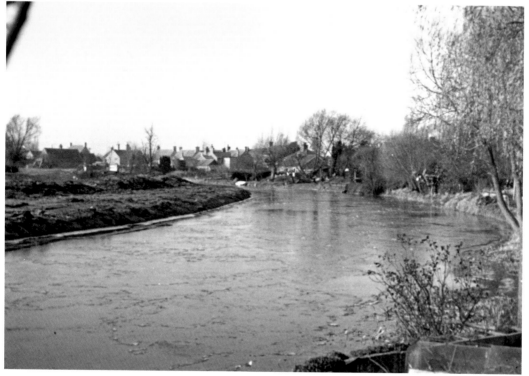

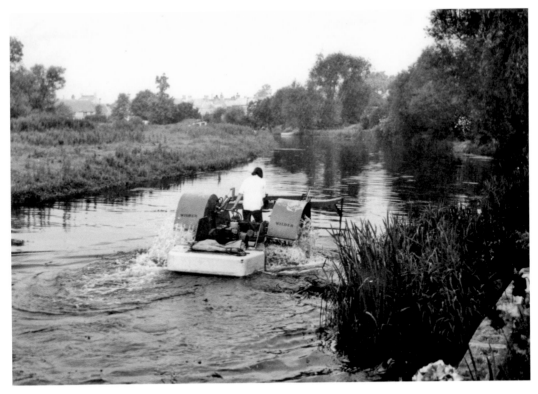

Cutting weed from the river bed in 1971 using a 'wilder' cutter, carried out annually.

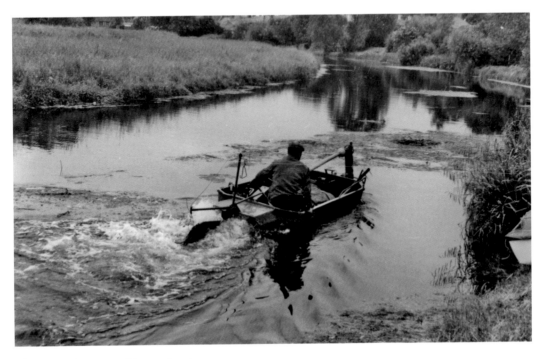

This time using a punt-like weed cutter, 1972.

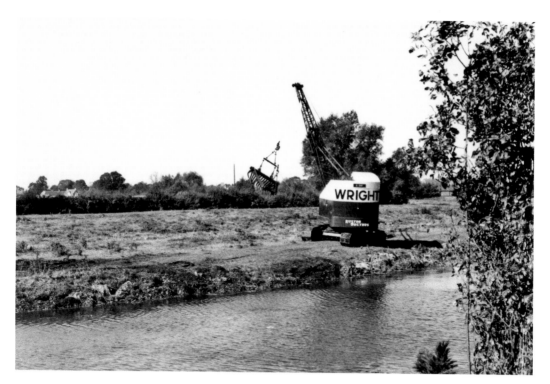

A small Ruston Bucyrus dragline taking weed from the river bed.

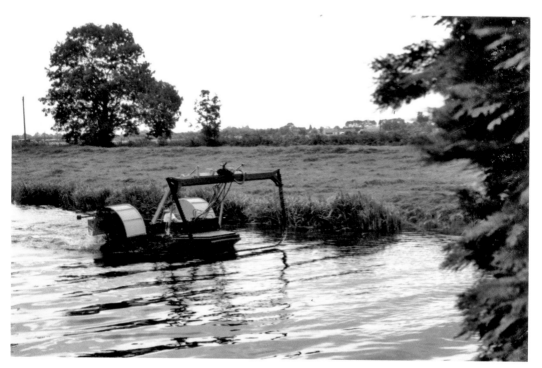

A large paddle-type weed cutter, 1987.

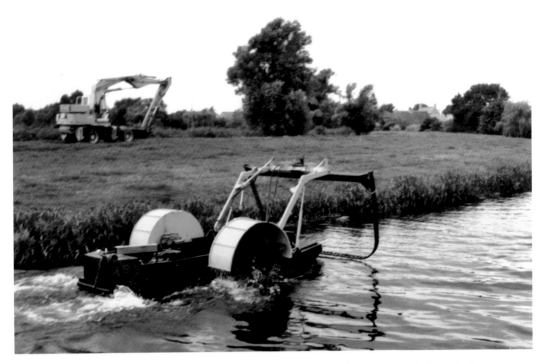

Paddle-type weed cutter on the bank , an internal drainage board dragline clearing the large drain over the bank, 1987.

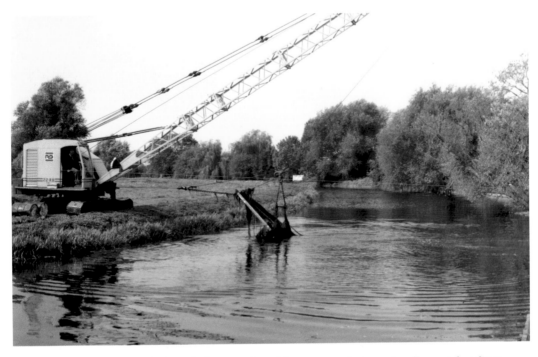

Clearing weed from the river bed. With the exception of the 1939–40 photographs, all were taken from our garden adjacent to Eastgate.

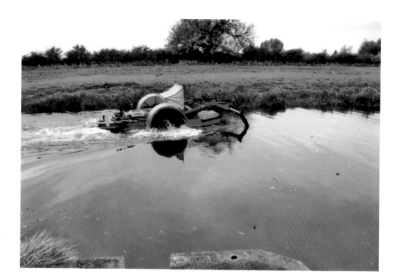

Cutting weed from the
river bank, October
2010.

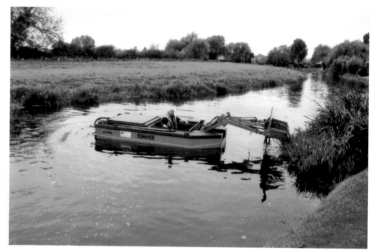

Taking excess reed
from the river bank,
October 2010.

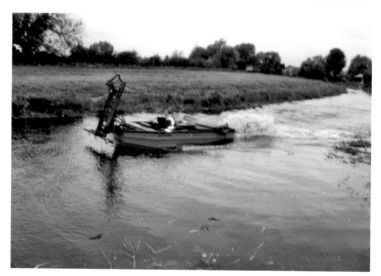

Taking the reeds to the
opposite bank, October
2010.

Dredging the river bed just beyond the bridge, 1991. The silt had to be taken away by lorry.

Repair work being carried out on Deeping St James Bridge (dated to the mid-fifteenth century) in 1992.

# 7

# A Frozen Welland

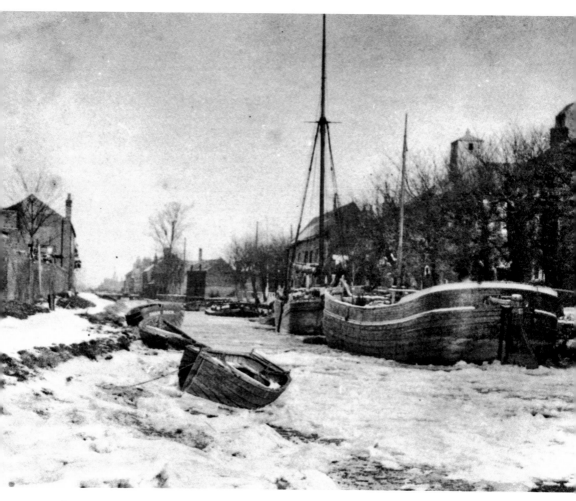

Earlier twentieth-century Humber. Keels iced up on the Welland at Spalding.

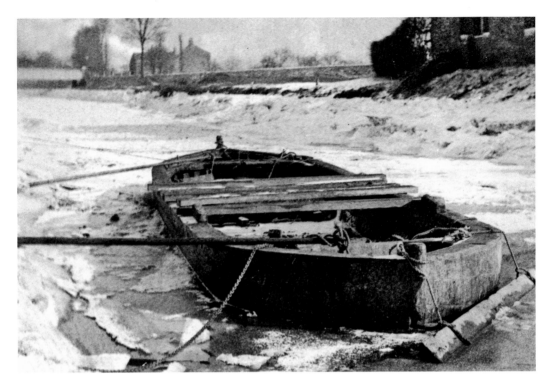

Early twentieth century, inland lighter iced up on the Welland at Spalding.

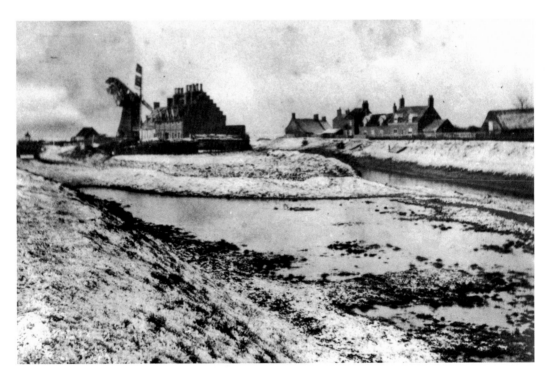

Showing Locks Mill near Spalding before 1899.

Taken from our garden, the Welland covered in ice and snow, December 1981, with priory church dedicated to St James in the background.

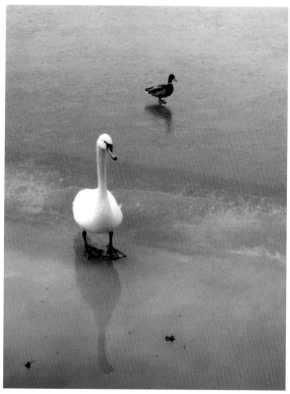

Taken from our garden – looking for a snack!

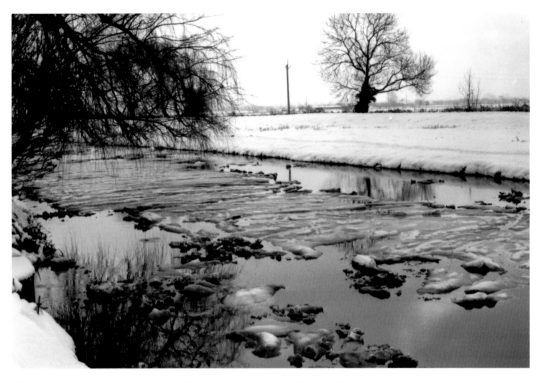

The thaw has set in, great masses of ice and melting snow floating downriver.

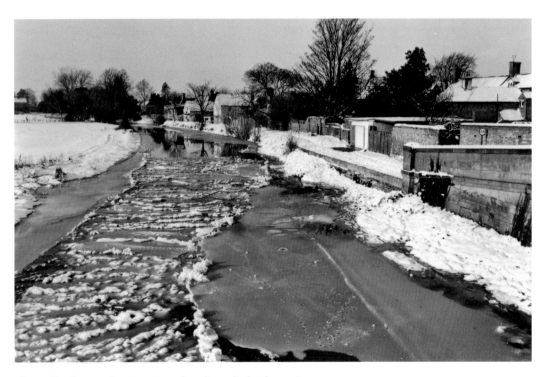

The Welland at Market Deeping, taken from the bridge, 1982.

# Conclusion

After the meandering course of the Welland through Leicestershire, Rutland, Lincolnshire and part of Cambridgeshire, it has finally reached its destination at Fosdyke, a marshland village on the Lincolnshire coast, where it discharges waters into the wash.

Readers may be surprised to see one of the last photographs in this book showing a fine display of flowers, and wonder what the connection to the River Welland is. The timbers on the roof of this fine display were some of the old timbers from the Old Fosdyke Bridge, rescued by Mr Reinhart Beiler, the owner of Baytree Garden Centre.

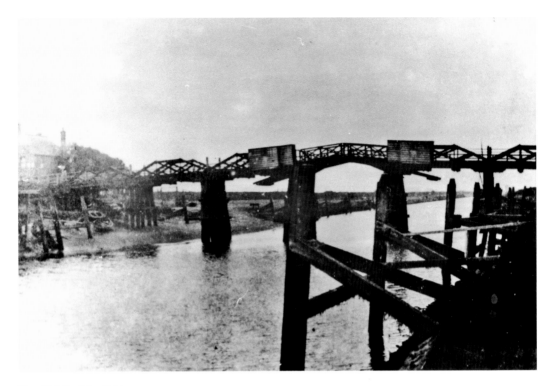

The Old Fosdyke Bridge.

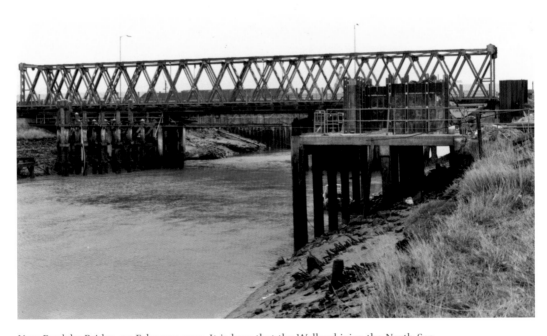

New Fosdyke Bridge, 24 February 1990. It is here that the Welland joins the North Sea.